MANCHESTER
THEN & NOW

IN COLOUR

CHRIS MAKEPEACE

The History Press

First published in 2012,
Reprinted 2013
This edition 2015

The History Press
The Mill, Brimscombe Port
Stroud, Gloucestershire, GL5 2QG
www.thehistorypress.co.uk

British Library Cataloguing in Publication Data.
A catalogue record for this book is available from the British Library.

ISBN 978 0 7509 6376 3

Typesetting and origination by The History Press
Printed in China.

CONTENTS

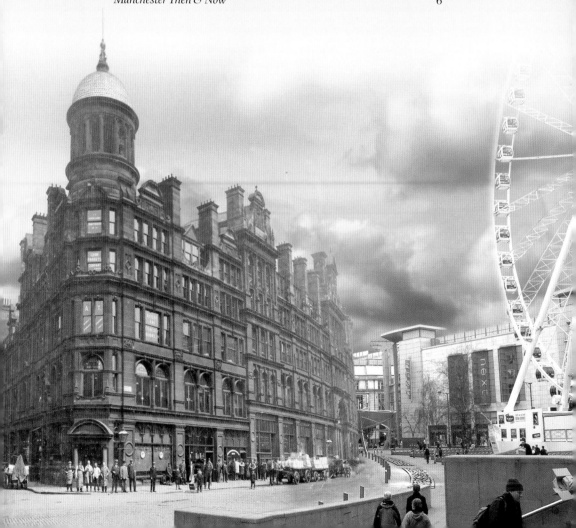

ACKNOWLEDGEMENTS

I would like to express my grateful appreciation to David Brearley who has taken all the modern photographs in this book. As a result of the changes that have taken place, there were times when it was not possible to get to the exact spot where the earlier photograph was taken from. My thanks are also due to the photographers who over the last 150 years have recorded the appearance of central Manchester. Without their work books such as this would not be possible. Also thanks should be expressed to the Manchester Local Studies Department who over the years have collected and preserved so many images of central Manchester that it is possible to obtain a very good impression of what the city looked like. Finally, I would also like to express my thanks to my wife Hilary, for her support and for reading the text and making many helpful suggestions about it.

ABOUT THE AUTHOR

Chris Makepeace has lived in the Manchester area for about fifty years and has a particular interest in the city's history from the mid-eighteenth century onwards. He started work as a librarian with the Manchester Local History Library and currently teaches local history. He has written seventeen books on the history of Manchester to date, and belongs to several local history societies.

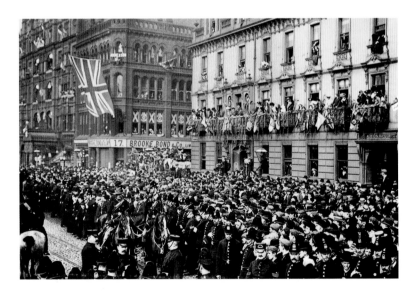

A huge crowd assembles to watch the unveiling of Queen Victoria's statue by Lord Roberts in 1901.

INTRODUCTION

During the late eighteenth and nineteenth centuries, Manchester grew out of all recognition from a market town to a major industrial city that was to have political and economic influence both at home and abroad. Between 1772 and 1801 the population rose from around 22,000 to over 70,000 and had reached almost 187,000 by 1851. It was not until 1838 when the townships of Manchester, Chorlton-on-Medlock, Ardwick and Cheetham were united to form the borough of Manchester. At the end of the nineteenth century these boundaries were altered as Manchester expanded to include areas such as Rusholme, Withington, Didsbury, Gorton, Crumpsall, Blackley and Levenshulme. Finally, in 1931, Wythenshawe was added to the city and Manchester assumed the shape and size it is today.

The expansion of Manchester was initially brought about by those who could afford it moving away from the congested and unhealthy central area to more pleasant surroundings outside, but as the nineteenth century progressed, commerce and business began to replace the residential property in central Manchester, leading to the enforced movement of working people to the suburbs. At the same time, the number of white-collar workers in Manchester grew. These workers began to take advantage of the improvement of road transport and gradual reduction of fares brought about first by the horse tram and then the electric tram. By the early twentieth century, central Manchester was becoming deserted by night as those who worked there left for their homes. Central Manchester was now a place of shops, offices, warehouses and financial institutions.

There have always been changes taking place in the townscape of central Manchester. Some of these have been planned as the result of actions taken by the local authority to improve conditions or access to the centre. However, in the twentieth century, although there has been planned change, much of it has been brought about by events beyond the control of the city council. The destruction of large areas of central Manchester in the Manchester Blitz of Christmas 1940 meant that there was a need to consider how these buildings should be replaced, and there was also the realisation that in some areas buildings were 'past their use-by date' and needed major refurbishment or even replacement. The result was the massive rebuilding programme that took place in Piccadilly and along Market Street between the late 1950s and early 1970s.

Between the mid-1970s and 1996, the changes that took place in the townscape were relatively small scale compared with that of the previous decade, whilst at the same time, the concept of 'facadism' (retaining the old façade of a building and stitching a new building on the back) began to appear. There was also a greater emphasis on trying to find new uses for some of the prominent old buildings, such as the conversion of Watt's Warehouse into a hotel and a theatre.

In June 1996, when an IRA bomb on Corporation Street destroyed a number of post-war buildings and severely damaged many others, the opportunity arose to examine what had been achieved since 1945 and to rethink how part of the city centre should look. At the same time, Manchester was preparing to host the 2002 Commonwealth Games, so it was necessary to enhance the appearance of the city centre. The face of central Manchester changed at a rate faster than at any other time in its history: familiar buildings and landmarks disappeared and new buildings appeared in their place, and new vistas, some of which may not have been seen for almost two centuries, opened up as buildings were demolished.

Since 2002, further changes have taken place such as the enlargement of the Arndale Centre, the extension of Metrolink to link some of the surrounding towns as well as the southern suburbs to central Manchester, and further attempts to restrict traffic in the shopping area. No doubt, Manchester will continue to grow and change over the years.

PICCADILLY STATION

WHEN THE MANCHESTER and Birmingham Railway (later the LNWR) opened in 1842, its Manchester terminus moved from a temporary one at Bank Top to Store Street (later renamed Manchester London Road). Parliament insisted that the station was shared with the Manchester Sheffield and Lincolnshire Railway (MS & L), which led to friction between the two companies despite the fact that both had separate facilities. As passenger traffic increased during the 1850s, the station and its facilities became inadequate and there were demands for improvements to be made. At first the LNWR dragged its feet, but eventually a new, larger station was built, opening in 1866. To prevent a recurrence of the disputes between the two companies, their respective areas were carefully demarcated. Further alterations were made by the LNWR in the 1880s, when four extra platforms gave the station the appearance it has in this early twentieth-century photograph (right).

THE ELECTRIFICATION OF the railway from Manchester to London resulted in major changes to Manchester London Road station.

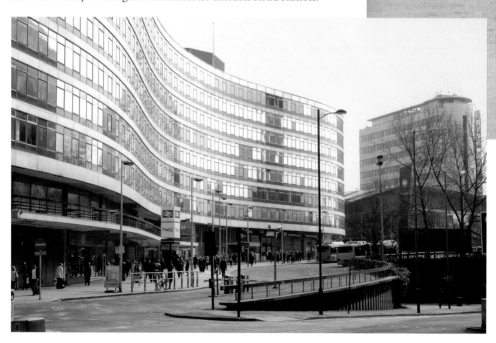

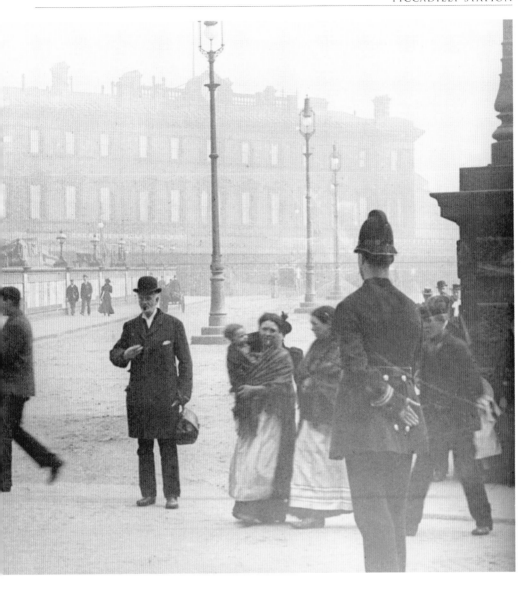

Not only was work necessary to the track but it was also decided to improve passenger facilities. A new booking hall was built and the station was renamed 'Manchester Piccadilly'. By the end of the twentieth century, these buildings looked rather drab. When Manchester was given the right to stage the Commonwealth Games in 2002, it was decided to remodel the station and passenger facilities with a new booking hall, an additional entrance on Fairfield Street for those arriving by car or taxi and improved access to Metrolink. The approach from Piccadilly was also closed to all vehicles except the free buses used to link central parts of the city with the railway stations. The modern photograph shows the refurbished front of the station together with Gateway House, designed to follow the curve in the approach to the station and built between 1967 and 1969 on the site of former railway warehouses.

HOTELS IN PICCADILLY

THIS ILLUSTRATION FROM the early twentieth century shows the section of Piccadilly between Newton Street and the Piccadilly station approach. Originally it was a mainly residential area, but by the middle of the nineteenth century its character had begun to change, with commercial buildings and hotels replacing the domestic property. Amongst the hotels that were built or opened were the Brunswick Hotel, the Imperial Hotel, the Hotel des Etrangiers, the Waterloo Hotel and, at the corner of Piccadilly and Portland Street, the Queen's Hotel. Census returns indicate that many people staying in these hotels came from abroad and may have been in Manchester for business purposes. In the background are the buildings facing Piccadilly Gardens, including St Margaret's Chambers, completed in 1892, on the corner of Newton Street and Piccadilly. The small building next to it, partially obscured by the tram, was originally a

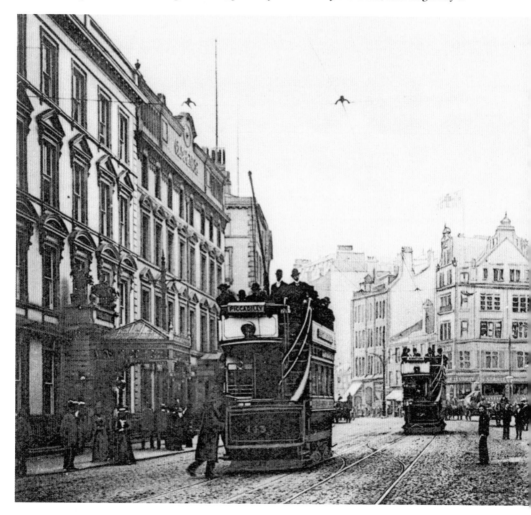

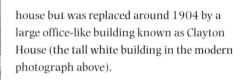

house but was replaced around 1904 by a large office-like building known as Clayton House (the tall white building in the modern photograph above).

THE MODERN PHOTOGRAPH above clearly shows the changes that have taken place on the left-hand side of the road where modern buildings have replaced those of the nineteenth century. The building on the extreme left is an extension to Hoyle's Warehouse that has been converted into a hotel, whilst the white-walled building was built in 1911 for the Union Bank of Manchester. The changes to the buildings on the right-hand side have been limited so that it, for the most part, retains the appearance it had in the later nineteenth and early twentieth century. Probably the oldest of these buildings is the white-painted one on the right-hand side of the photograph, which was originally the Brunswick Hotel and dates from the early nineteenth century.

TEXTILE WAREHOUSES

IN THE LATTER half of the nineteenth century, parts of central Manchester were dominated by textile warehouses similar to the ones shown here on the corner of Aytoun Street and

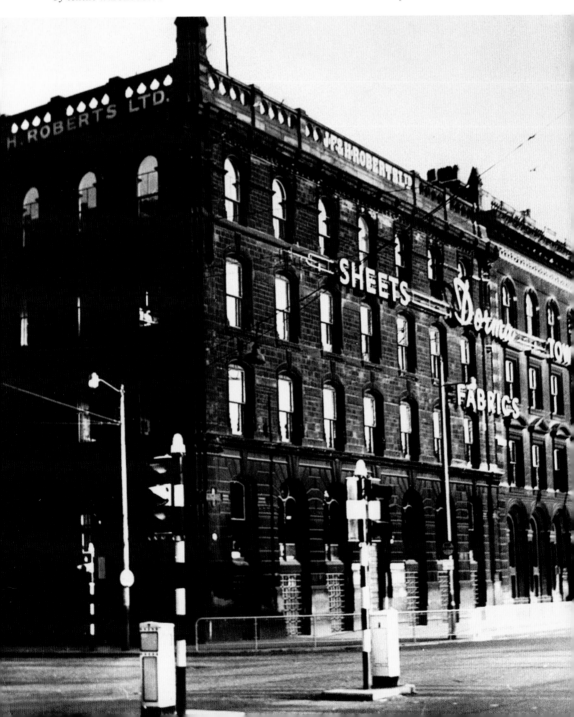

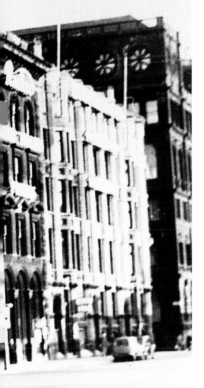

Portland Street. Some were involved in the home trade whilst others specialised in exports. Many of the warehouses had impressive stone façades at the front but common brick in those areas the public could not see. The internal layout of the warehouses tended to be very similar irrespective of their use. The basement was used for packing, a ground floor, accessed up a flight of steps, was used for offices, waiting rooms and show rooms, and the upper floors were used for storage. The warehouses in the foreground stood between Aytoun Street and Minshull Street and were occupied by two firms of cotton manufacturers, J.F. & H. Roberts and Ashton Bros. These warehouses were demolished in the early 1970s and replaced by the building shown in the modern photograph above.

THE BUILDING SEEN in the centre of the modern photograph above was intended to be a modern office block. In 1974-5 it was acquired by the newly-created Greater Manchester County Council and became known as County Hall. With the abolition of the county council in 1986, the building was refurbished, sold and renamed Westminster House. On the extreme left of the photograph is an example of a warehouse where the façade was retained, providing some continuity with the original appearance of the area.

WATTS' WAREHOUSE

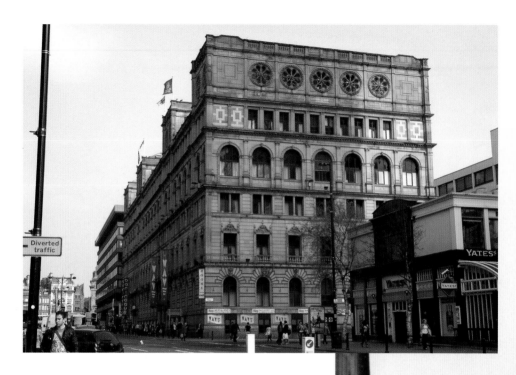

PERHAPS MANCHESTER'S BEST known warehouse was that designed for the home trade merchants J. & S. Watts on Portland Street. John Watts founded his haberdashery and drapery business in 1792. In the mid-1830s, it was decided to concentrate on the wholesale side of the business, selling the retail side to three employees: Kendal, Milne and Faulkner. These employees continued to develop the business, which is known today as Kendal Milne. After about twenty years of renting warehouses, the Watts family finally decided to build their own. They acquired a plot of land on Portland Street and commissioned Travis and Mangnall to design the new warehouse, which opened in 1858 at a cost of around £100,000. In the late nineteenth century, the firm's catalogue ran to almost 400 pages and it employed over 1,000 people, either in the warehouse itself or as travelling salesmen. It was said that all orders received in the first post were dispatched the same day. The early twentieth-century illustration of Watts' Warehouse on the right also shows the adjacent warehouses that dominated the street scene.

BY THE EARLY 1970s, Watts' Warehouse was no longer in the hands of the Watts family but belonged to a larger textile company who decided that they no longer wanted the building. It was acquired by property developers, but the economic crash of the mid-1970s resulted in their bankruptcy. The liquidator sought to demolish the building, a move that led to a public outcry and to a change in attitude towards conserving Manchester's architectural heritage by the city council. Permission to demolish the building was refused and eventually a developer came forward with plans to convert the building into a hotel. The modern photograph of Watts' Warehouse on the left, which is now known as the Britannia Hotel, shows the architectural splendour of this building, which to many Mancunians is an important part of the city's commercial and architectural heritage.

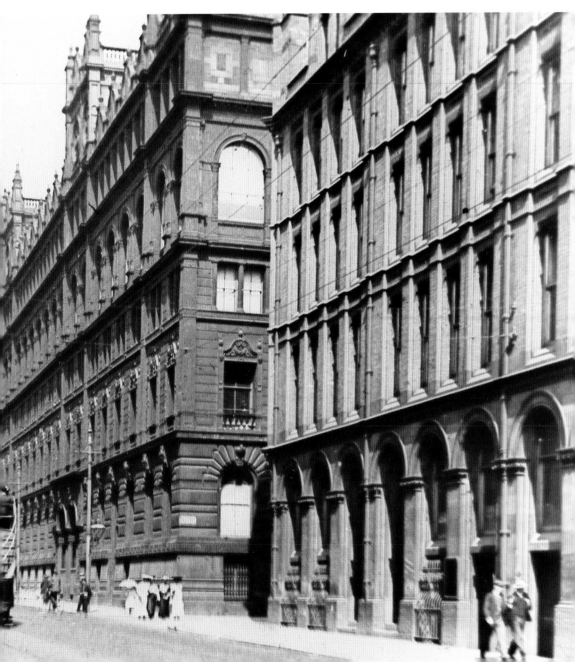

PICCADILLY ESPLANADE

ORIGINALLY KNOWN AS the Daub Holes, Piccadilly Esplanade came into existence in the eighteenth century with the erection of Manchester Royal Infirmary. During the nineteenth century, there were several attempts to erect fountains there, but these were not successful, so in the mid-1850s, it was decided to pave the area and place the statues of the Duke of Wellington, Robert Peel, John Dalton and James Watts there. This early twentieth-century postcard not only shows the Esplanade but also Manchester Royal Infirmary, whose building dominated Piccadilly

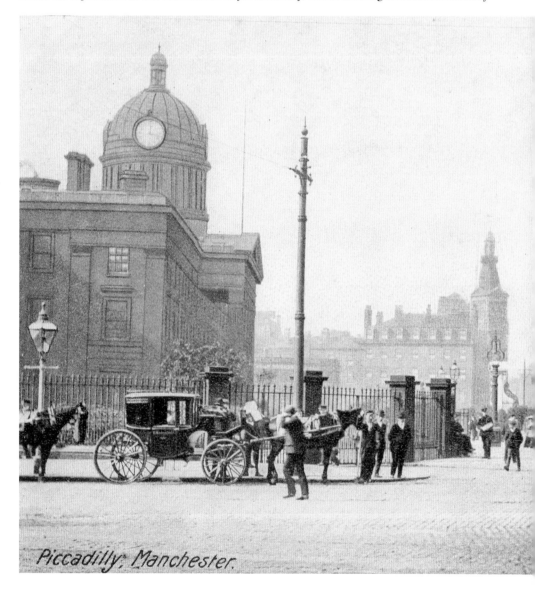

Piccadilly, Manchester.

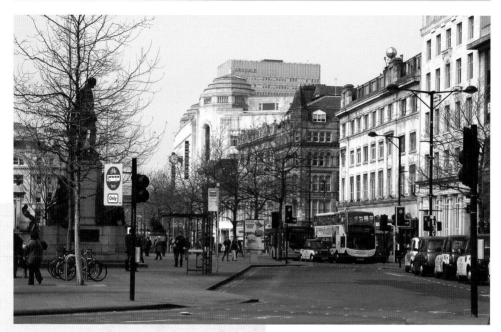

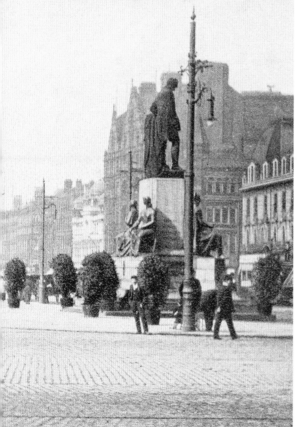

between 1755 and 1908 when it moved to its present site known as Stanley Grove, but to most people it is on Oxford Road, Chorlton-on-Medlock.

IN PREPARATION FOR the Commonwealth Games in 2002, Piccadilly and its Esplanade underwent a transformation from a rather tired looking area to one that it was hoped would be a focal point in the centre of the city. The work involved filling in Piccadilly Gardens, creating a water feature and reducing the width of the road to benefit pedestrians. The statues on the Esplanade were retained although the widened pavement gives the impression that they have been set back. Although buses and taxis still use the section of Piccadilly between Oldham Street and Lever Street, private cars are now banned and buses wait for passengers either in the nearby Parker Street bus station or in Lever Street and Oldham Road.

15

PARKER STREET
BUS STATION

DURING THE INTER-WAR period, the amount of traffic using the roads of central Manchester increased considerably. Not only were there trams and buses but also a growing number of motor vehicles, especially private cars. In order to try and reduce congestion, a number of one-way systems were introduced including one around Piccadilly, but this created problems

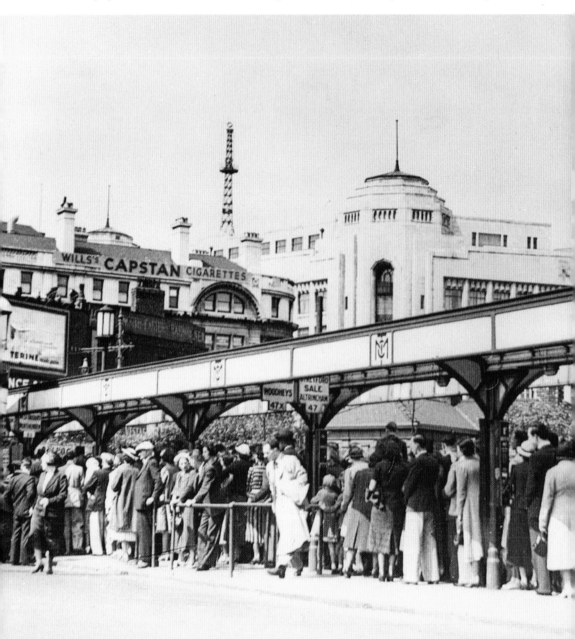

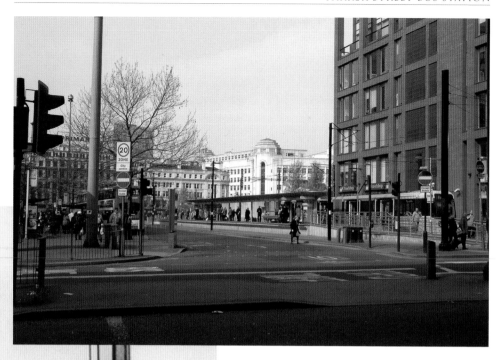

for buses and trams that waited in Piccadilly to commence their next journey. In 1931 it was decided to establish a bus station on Parker Street, behind the former Royal Infirmary site, where buses could wait. Bus stands were erected with shelters for passengers to protect them from the elements, as the late 1930s photograph on the left clearly shows.

SINCE IT OPENED, Parker Street bus station has been refurbished on several occasions, but the most dramatic change took place in the late 1980s and early '90s when the Metrolink tram system was introduced. The first trams ran between Manchester Piccadilly station, Altrincham and Bury, some of which passed through Piccadilly where a tram stop was built. The modern picture above shows one of the most recent trams about to depart from Piccadilly for Piccadilly station, while nearby buses wait for their passengers. The red building on the right stands close to where a building was erected after the Royal Infirmary had moved to Oxford Road in order to deal with accidents and emergencies that occured nearer to the central area where so many people work and shop.

LEVERS ROW

UNTIL THE EARLY nineteenth century, the area now known as Piccadilly was called Levers Row after the Lever family of Alkrington Hall, near Middleton, who owned land in the area. Their town house eventually became the White Bear Hotel and was situated just to the left of the picture below. In the late eighteenth century, Piccadilly was a popular area for members of the medical profession to reside as it was close to the infirmary. Gradually, the nature of the area changed as domestic residences were replaced by commercial properties such as the Mosley Hotel (extreme left) and the

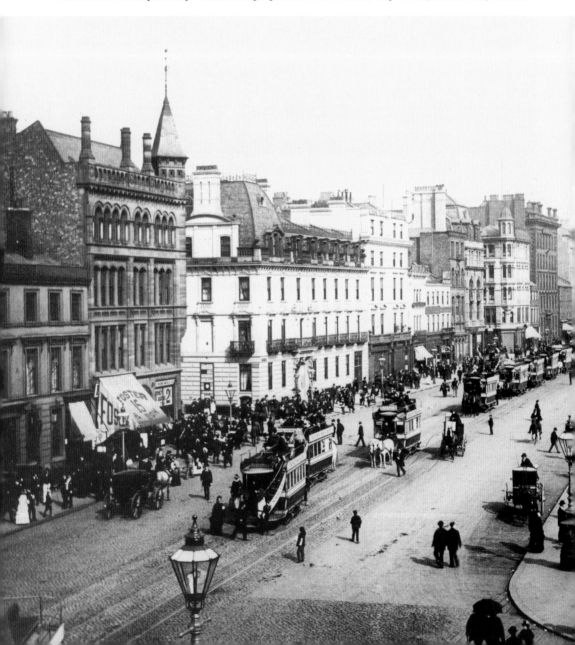

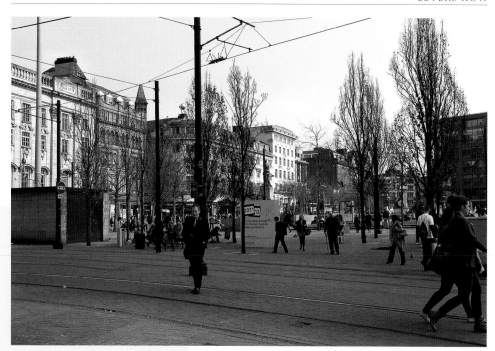

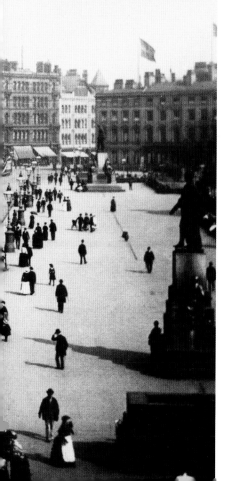

Albion Hotel (on the corner of Oldham Street). On the far side of the Esplanade, flying a large flag, is the Queen's Hotel, which became one of Manchester's leading hotels in the latter half of the nineteenth century.

THE REFURBISHMENT OF Piccadilly Esplanade and the Piccadily Gardens in the early twenty-first century resulted in the planting of trees and a new water feature. The water feature can just be seen on the right of the modern picture above, but the trees prevent the clear view of the buildings that was previously possible. Many of the buildings on the left date from the twentieth century, with the exception of the brown stone building built in 1881 that has had another floor added since the previous photograph was taken. The building on the extreme left, now occupied by Boots, is on the site of the Mosley Hotel, which closed around 1922. The hotel was then converted into the Piccadilly cinema, which closed in 1937. The building with the globe on the roof is the former Woolworths building, which opened in 1926 replacing the Albion Hotel, and the tall white building next to it, which dates from around 1928, was the home of the BBC in Manchester until around 1976.

19

OLDHAM STREET

IN THE LATE nineteenth century, the part of Oldham Street closest to Piccadilly was regarded as a Mecca for ladies as it was where the main haberdashery and ladies fashion shops were located as well as Affleck and Browns store. The early twentieth-century illustration on the right shows how busy Oldham Street was at that time; amongst the shops that ladies could visit were Goodsons (mantle manufacturers), Foster and Sons (trimmings dealers), Lowes (drapers) and the mantle makers Alfred Steindall and Robert Lomas. If they were in need of a new servant, there was even a servants' registry at No. 6 Oldham Street, which is on right-hand side of the picture.

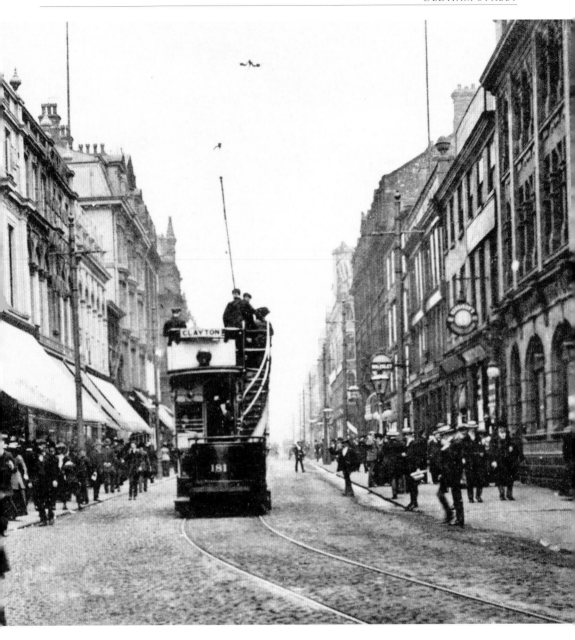

DURING THE SECOND half of the twentieth century, the importance of Oldham Street for shopping gradually declined. The haberdashery and ladies' fashion shops of the early twentieth century gradually disappeared and were replaced by less glamorous ones. The opening of the Arndale Centre further reduced the importance of Oldham Street, with stores like C&A relocating to the new development. Some of the vacant buildings have been converted into apartments as part of the move to bring back residential accommodation to the centre of Manchester, while some have become cafés and bars.

THE JUNCTION OF MARKET STREET, MOSLEY STREET AND PICCADILLY

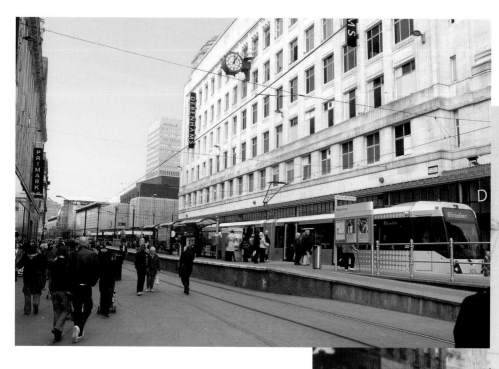

ONE OF THE busiest places in central Manchester was the junction of Market Street, Mosley Street and Piccadilly shown in this early twentieth-century photograph (right). It was often said that it was quicker to walk from Piccadilly to the Exchange rather than travel by tram due to the congestion of Market Street. At this point, horse-drawn vehicles, electric trams and pedestrians mingle regardless of the danger to life and limb. On the left is the Royal Hotel and Bridgewater Arms, which had been built in the 1770s as a private house but was converted to a hotel in the late 1820s. Beyond it is the lower section of the tower of Lewis's store, the opening of which in 1885 began a retail revolution in the city as it opened on Saturday afternoons when other similar

shops were closed. On the right is the warehouse of John Rylands & Co., which covered a large area between Market Street, High Street and Tib Street and was, at this time, very profitable. The building in the picture was replaced in the early 1930s by the present building.

THE CREATION OF the Metrolink tramway required the building of platforms to allow access to the tram. This platform is located at the top end of Market Street, outside Debenham's store, and runs trams from Altrincham, Bury and Chorlton-cum-Hardy, thus providing easy access to Manchester's main shopping street. The tram in the modern photograph is on the Bury to Altrincham route and will stop next at the corner of Mosley Street and Piccadilly. Further routes are planned to link Oldham and Ashton-under-Lyne with Manchester whilst the line to Chorlton-cum-Hardy is being extended to East Didsbury. The building occupied by Primark is the former Manchester branch of Lewis's, and the former Rylands building is now owned by Debenhams who had taken over Pauldens. Pauldens had originally moved into the building in 1956 after a fire had destroyed their premises on Stretford Road.

MARKET STREET

MARKET STREET IS one of Manchester's oldest streets and was originally called Market Stede Lane. Towards the end of the eighteenth century, when a road was built linking central Manchester to the Ardwick, Market Street became the main access to the town from the south, with the result that this rather steep street with an irregular building line caused by with buildings encroaching on the pavement, became not only congested, but also a danger to pedestrians and other road users. During the 1820s, the gradient was reduced and the road widened to create a uniform width. Many of the new buildings erected at the time of the widening combined retail facilities with residential accommodation above, but as the nineteenth century progressed, the residential element declined and the upper floors became workshops and offices. From time to time, new buildings replaced those of the

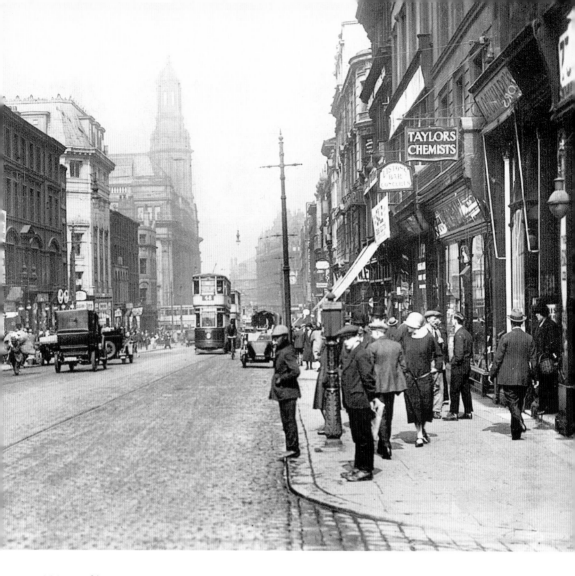

1830s and '40s creating an interesting streetscape. Gentlemen's outfitters were amongst those often to be found on Market Street, but there were many other retail businesses also to be found there. Amongst the businesses that can be seen in this 1930s photograph are those of Pitmans School, which was probably a secretarial college, and the Clarion Café.

MARKET STREET IN 2011 is completely free from traffic. Where cars, buses, trams, lorries and vans used to drive, there are now market traders, trees, seats and people undertaking surveys. The idea of creating a traffic-free Market Street was first proposed in the early 1900s, but nothing came of this until the 1970s when a start was made in reducing the amount of traffic, firstly by banning all traffic except delivery vehicles and buses, achieved by narrowing the roadway, and then in 1986 introducing full pedestrianisation. Although many of the buildings that can be seen in the 1930s photograph have been replaced, some have remained, such as the red-brick building partially hidden by the trees. Just visible over the bridge, linking the two sides of the Arndale Centre is the tower of the Royal Exchange, clearly visible in the earlier illustration.

MARKET STREET
CONTINUED

THE VIEW OF Market Street in the mid-1930s below shows some of the buildings that faced those in the previous picture. Shops predominated along Market Street although there was one place of entertainment, the Market Street sinema, opened by Provincial Cinematograph Theatre Ltd in 1914. In the 1930s, its owners claimed that it was 'the ideal house for Talkies'. It was renamed the Cinephone and although on a limb as far as Manchester's cinemas were concerned, continued to show films until its closure in 1974. Another well-known Manchester business, Yates Wine Lodge, is also visible in this photograph. Yates Wine Lodge shared the ground floor of the building occupied by the Albion Hotel with Boydell Brothers, a well-known and respected gentlemen's tailors in Manchester. The Albion Hotel had moved to Market Street in 1926 when its original premises in Piccadilly were acquired by F.W. Woolworth & Co. The tall building with

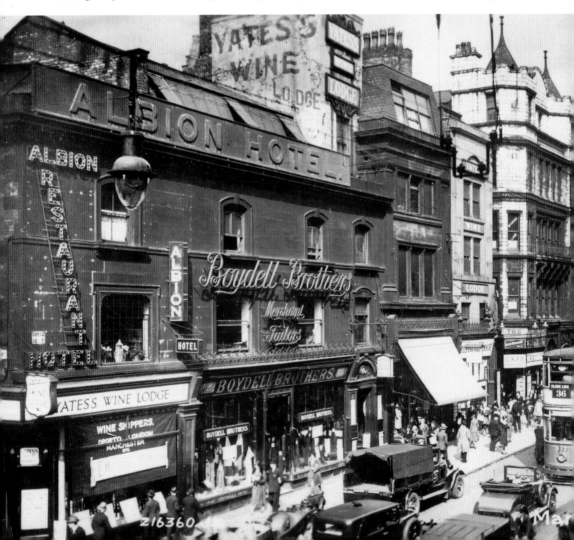

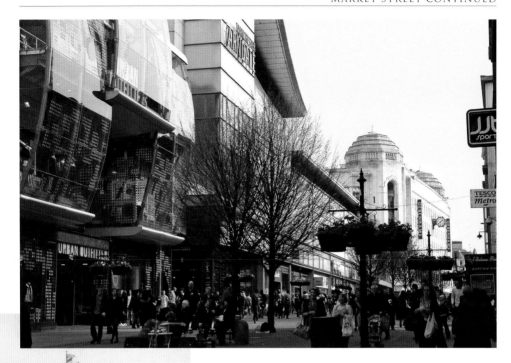

the mast in the background belonged to John Rylands and Co., and is now occupied by Debenhams. By the 1930s, Market Street was even more congested than it had been half a century earlier, with trams, motorcars, vans and cyclists all fighting for space on the road, whilst the pavements were busy with pedestrians, some of whom are seen here trying to cross the road.

DURING THE LATE 1960s and '70s, the area bounded by Market Street, High Street, Shudehill/Withy Grove and Corporation Street was cleared to make room for a major redevelopment, the Arndale Centre, which was one of Europe's largest undercover shopping centres at the time. Many of the buildings behind Market Street had been in poor condition and did require either replacement or extensive refurbishment, yet when the Arndale Centre opened it was subject to a lot of criticism (the centre's appearance, especially the yellow tiled exterior walls, and the threat to other shopping facilities in the city centre being the main objections). Despite criticism, the Arndale Centre attracted some of the biggest names in retailing like WHSmith, Littlewoods, Dixons and C&A as well as a number of smaller, specialist shops.

treet, Manchester.

27

TRAFFIC

UNTIL THE MIDDLE of the nineteenth century, the journey from central Manchester to Cheetham was a rather convoluted one involving streets not designed for large amounts of traffic. The situation was eased in 1846 when the first part of Corporation Street was completed as far as Withy Grove, the full length to Ducie Bridge and Miller Street being completed in 1850. Within a short period of time, the junction of Cross Street, Corporation Street and Market Street became a very busy one, so much so that by the beginning of the twentieth century, a policeman, and sometimes two, had to be placed on point duty to ensure the smooth running of the traffic. The photograph below, taken in 1914, shows that horse-drawn vehicles and electric trams were all mixed together, while pedestrians try to cross the road safely. The type of transport missing from

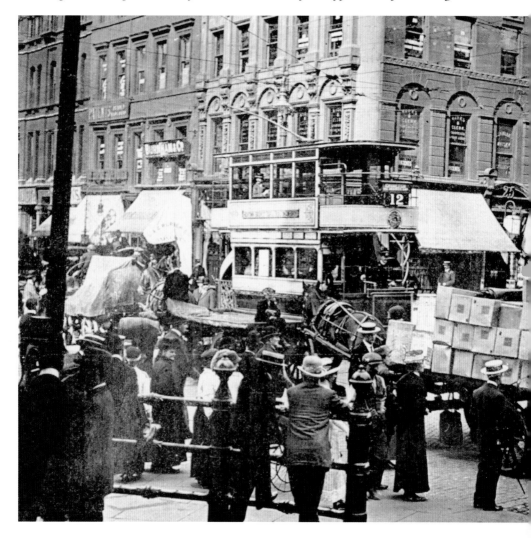

this photograph are motorised vehicles such as cars, lorries and vans, whose numbers were beginning to increase at this time.

THE PICTURE ABOVE shows the same junction almost a century later with a complete absence of traffic. Although this is the result of work taking place to the bridge across Corporation Street linking the Arndale Centre to the building housing Marks & Spencer and Selfridges, the major changes that had taken place after the 1996 IRA bomb had already reduced the traffic in the area with precedence being given to buses and taxis. As well as allowing changes to the traffic circulation in the area, the damage caused by the bomb enabled major changes to be made to the external appearance of the Arndale Centre, as can be seen in the modern photograph above: the yellows lines of tiles and right-angled corner of the building have been replaced with a more attractive façade.

MANCHESTER STATIONS

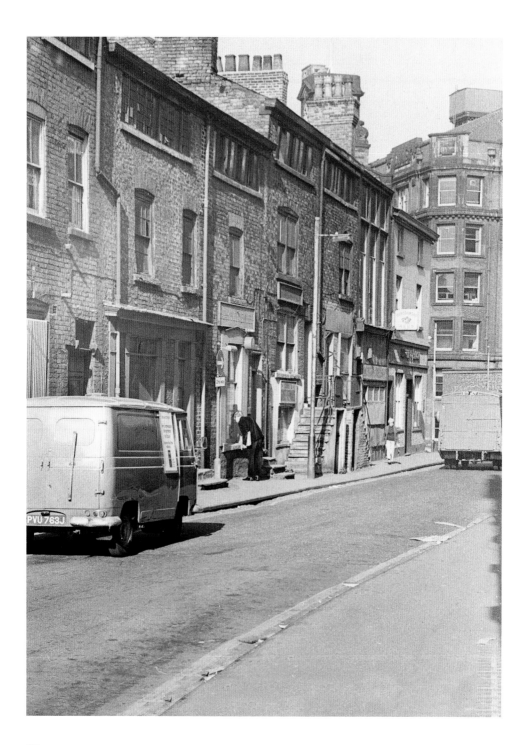

IN MANCHESTER, DIFFERENT stations served towns to the north and south of the city, there being no direct link between the stations and lines. During the nineteenth and twentieth centuries, various ideas were put forward to try and resolve this matter and to make it easier for passengers wanting to travel between Victoria and Piccadilly stations. Eventually it was decided to link lines to Altrincham and Bury by means of a tramway system through the centre of Manchester. To do this meant that track had to be laid along existing roads in central Manchester and in some places it was necessary to demolish property to accommodate it. One of the streets affected was Bradshaw Street, shown opposite in the early 1970s. This was one of the earliest areas to be developed as Manchester expanded in the late eighteenth century. By the time the picture was taken, many of the original buildings in the area had been demolished to enable the CWS to develop its headquarters. Although some of the properties in this area were cottages, many were three-storeyed, cellared buildings with workshops on the upper floor, similar to the ones shown in this photograph. In 1969, these properties in Bradshaw Street were occupied by small firms such as general warehousemen, electrical suppliers, shoe repairers and jewellers; the property on the end was a public house.

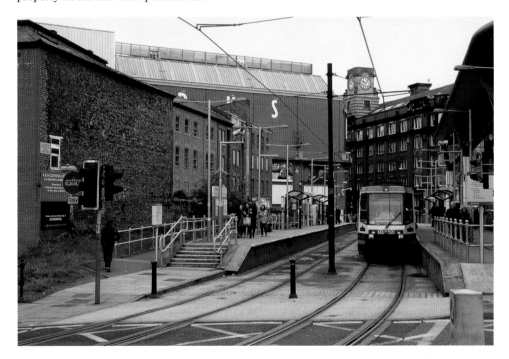

WHEN METROLINK OPENED, there was no station between Victoria station and Market Street, but as the post-1996 \development took place, it was decided to close the bus station under the Arndale Centre (never very popular on account of its low entrance and roof and lack of adequate ventilation) and create one on Shudehill. To make it easier for passengers, a new Metrolink station was opened to provide an interchange between tram and bus. The modern photograph above shows the Shudehill tram shop with the bus station to the right of it and the rear of the Printworks entertainment complex and one of the older CWS buildings in the background.

SHUDEHILL

ALTHOUGH SHUDEHILL HAD existed for many centuries as one of the routes into the town from the east, it was not until the eighteenth century that it began to have any significance, when some of Manchester's markets began to be relocated from the central area due to the growth in the number of markets and the use made of them by the rapidly growing population. During the first half of the nineteenth century, most of Manchester's markets were moved so that by the end of the

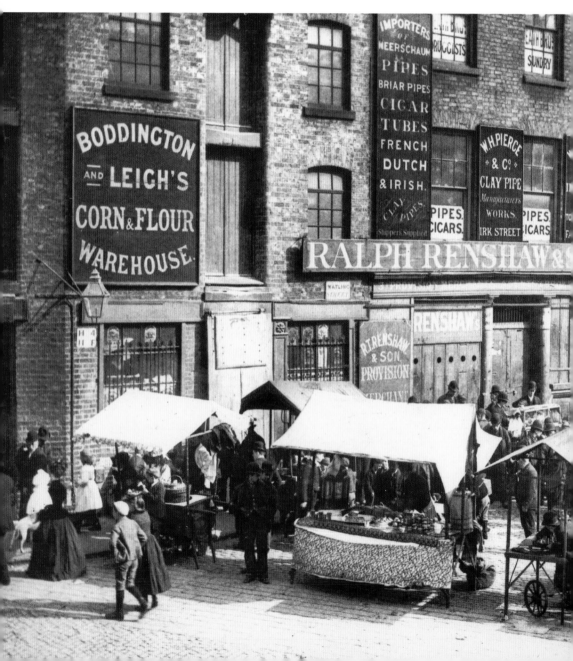

nineteenth century, Shudehill and the Smithfield area was where all Manchester's major markets were to be found. Amongst these markets was the Hen Market, shown here, which was at the corner of Watling Street and Shudhill/Withy Grove. Here it was possible to purchase not only chickens but also more exotic birds, such as peacocks, and even small mammals, like ferrets. In the background of the 1890s photograph is one of the many warehouses that existed in the area, which supplied a wide range of material from hay and straw to fancy goods.

IT CAN BE difficult to pinpoint exactly where some nineteenth- or twentieth-century photographs were taken in parts of central Manchester because of the large amount of the redevelopment that has taken place. Sometimes, however, it is possible to locate where a particular building or market was with the aid of old maps – as is the case here. This view of Shudehill shows not only some of the original buildings, like those on the left, but also the rear of the Arndale Centre and the office and residential block that dominates it. What appears to be an impressive entrance is in fact the entrance to a multi-storey car park, which was built on the site of the old Hen Market.

WHITTLE STREET LOOKING TOWARDS THE CIS TOWER

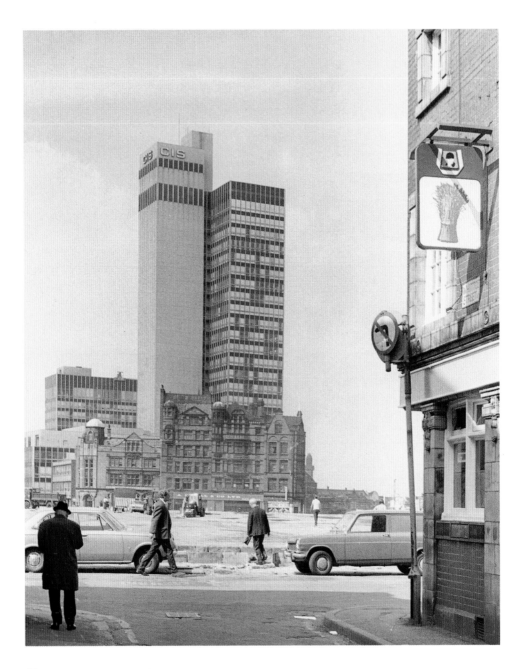

THE EARLY 1970s photograph opposite, taken from the end of Whittle Street, looks across the site of the former Smithfield Market towards Shudehill and the CIS Tower, which was the tallest building in Britain when it was completed in 1962. The move that took place in the 1820s affected those stalls that were located in the Market Place and at Smithy Door and was made because the Market Place was over-crowded and dangerous, with delivery vehicles and pedestrians mingling together. By the end of the nineteenth century, the site included a wholesale fruit and vegetable market, and the whole area was very busy from early in the morning to late in the evening. The building dwarfed by the CIS tower was erected in the late nineteenth century for a firm that was involved in the manufacture and distribution of umbrellas. To the right of the CIS building is the ventilation shaft of Strangeways Prison, opened in 1868.

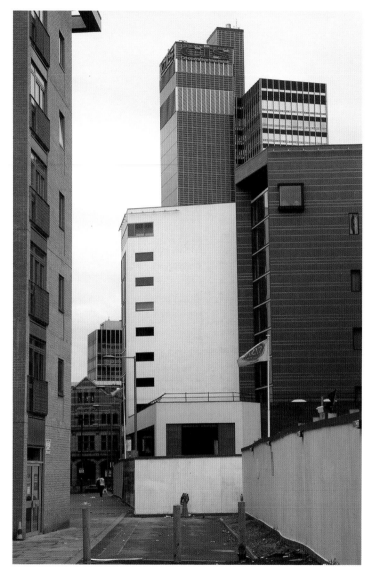

DURING THE LATE twentieth and early twenty-first centuries, there has been a concerted effort to encourage people to live in central Manchester. This has not only involved the conversion of former warehouses into apartments but also the erection of new apartment blocks like the ones in the foreground of this illustration, which were built on the vacant site shown left. In the background, the former umbrella warehouse and the buildings of the CIS are still visible – a link with the previous view of the site.

CATEATON STREET

CATEATON STREET IS one of the oldest streets in central Manchester, the name being derived from the Anglo-Saxon meaning 'hollow way'. In the sixteenth century, it was said that the houses stood high above a sunken roadway although there is no evidence of

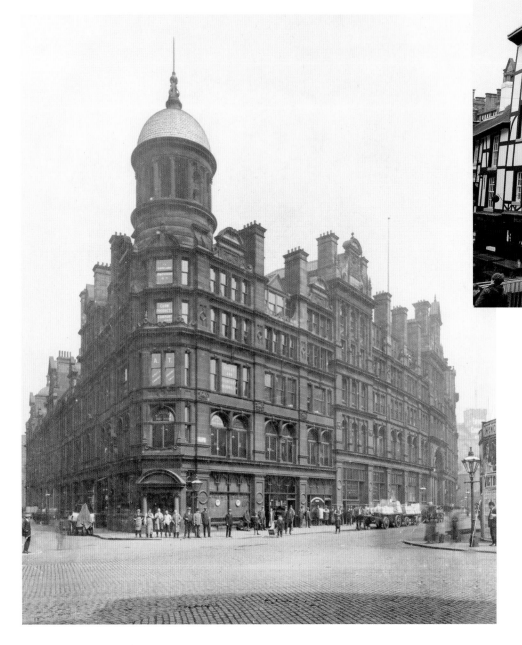

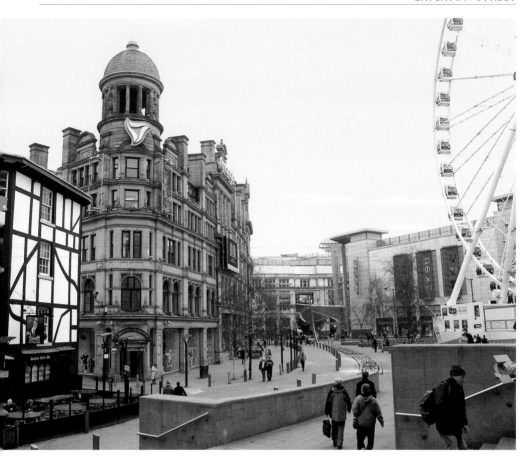

this today. Close by was a feature often described as 'Hanging Ditch' whose origins are a mystery, but it is believed to be connected with the now disappeared River Dene. This 1909 image of the junction of Cateaton Street and 'Hanging Ditch' ('Hanging Ditch' being the road in front of the building) shows the Corn and Produce Exchange, which was erected between 1895 and 1904 to provide a meeting place for those engaged in importing food into Manchester. Like the Royal Exchange, it had a large central floor that was surrounded by offices, while in the basement there were cold stores for perishable produce.

THE IRA BOMB in June 1996 caused such severe damage to buildings around the junction of Cateaton Street and Corporation Street that they had to be demolished. This allowed the authorities to consider the most appropriate way to use this important area close to the heart of the original town of Manchester. It was decided to partially pedestrianise Cateaton Street and to stop traffic passing in front of the former Corn and Produce Exchange (renamed the Triangle) to create a new public open space. Later, a giant Ferris wheel was erected that allowed imposing views of the city centre and the surrounding area. The black and white building on the left is Sinclair's Oyster Bar, whose site is now covered by an enlarged Mark & Spencers' building, and is located where the Ministry of Labour Appointments Office was situated in the earlier image.

CORPORATION STREET

WHEN CORPORATION STREET was constructed in the mid-nineteenth century, it cut through poor-quality houses, providing the opportunity to improve the access to Victoria station using what remained of Todd Street. When Corporation Street was completed there was only one building that pre-dated its construction, the Manchester Arms whose main entrance was on Long Millgate. The rear entrance to the pub is hidden behind the shop with the sign 'Shoe Repairs'. Behind these buildings in the foreground and linking Fennel Street with Todd Street, was Lancaster Arcade, built in the early 1850s. During the 1960s, when the photograph on the right was taken, the two buildings on the left were occupied by a number of small businesses including representatives of cotton-spinning firms, turf accountants, a photocopying consultancy and an employment agency.

IN THE 1970s, the buildings in the old photograph between Fennel Street, Todd Street and Long Millgate were

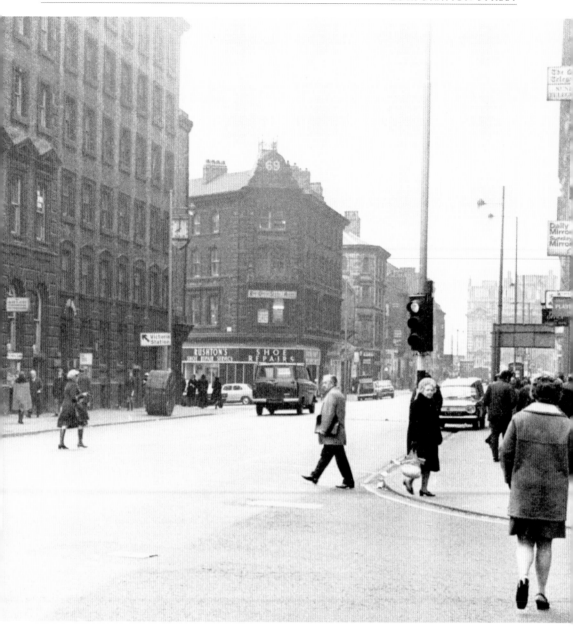

demolished as it was intended that a hotel should be built on the site, but nothing came of these proposals. For many years the site remained vacant, used as a car park. Eventually it was redeveloped with this tall glass structure as the centre piece. Originally, the building was the home of 'Urbis', an exhibition centre devoted to urban development and the history of Manchester. It was not as successful as had been anticipated and ran into financial difficulties. Eventually, a new use was found for it and it became the home of the National Football Museum, which had originally been at Deepdale Park, Preston.

EXCHANGE STATION

WHEN VICTORIA STATION was opened by the Manchester and Leeds Railway (later the Lancashire and Yorkshire Railway) in 1844, it was shared with the London and North Western Railway (LNWR), who had taken over the Liverpool and Manchester Railway. The two companies operated from different ends of the station with the LNWR having the right to run its trains as far as Miles Platting Junction to gain access to its lines across the Pennines to Yorkshire via Stalybridge and Huddersfield. The 1878 photograph below shows the approach to the station from Victoria Street and the end of the station used by the LNWR. In the background is the building housing the L & Y booking office and other passenger facilities. The LNWR moved from Victoria station in 1884 to Exchange station, as the company was worried that it might be forced to move by the L & Y, which was expecting a rapid growth in passenger numbers. Eventually, by 1906, Victoria station had

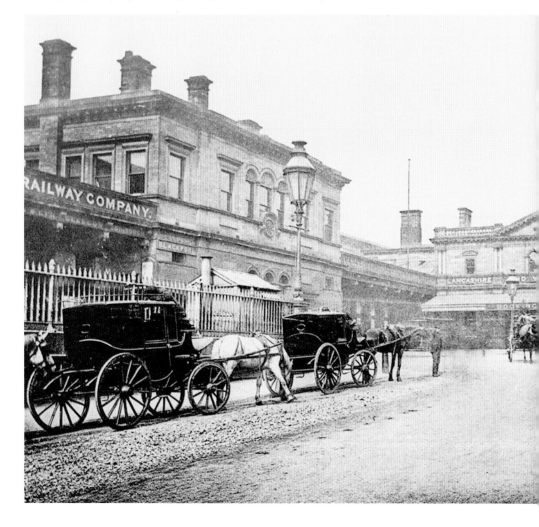

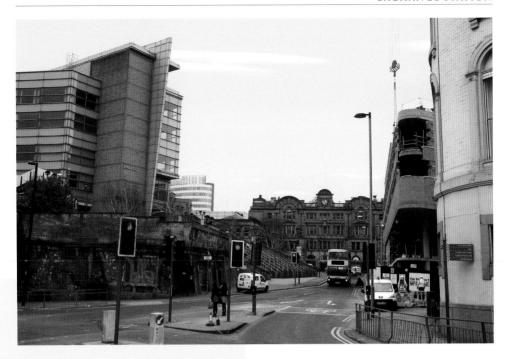

seventeen platforms with services to most parts of Lancashire and Yorkshire.

DURING THE LAST half of the twentieth century, there was a sharp decline in the number of people travelling into Manchester by train, leading, in 1969, to the closure of Exchange station. The completion a few years later of the Windsor link allowed trains travelling between Liverpool, Yorkshire and the North East of England and between Manchester and the Lancashire coast to be diverted from Victoria station to Piccadilly station. As Victoria station had no need for so many platforms, it was decided to simplify the network north of central Manchester and redevelop the site. An arena, now known as the Manchester Evening News Arena, capable of holding over 15,000 spectators was built, together with a multi-screen cinema and parking facilities. The new building on the right in the course of construction is part of Chetham's School of Music and occupies the site of the former L & Y headquarters.

MANCHESTER CATHEDRAL

THERE HAS BEEN a church on the site of the present Manchester Cathedral since before the Norman Conquest. Originally, it was a parish church of Manchester covering a parish of about 60 square miles. In 1421, Thomas de la Warre, lord of the manor and also a priest, expressed concern about the provision for the spiritual well-being of the inhabitants of the parish and obtained a charter to create a Collegiate church where there were several priests to take services and visit the out-lying areas. The church also had its dedication changed from St Mary's to 'St Mary, St Deny and St George' and the building was gradually rebuilt. In the nineteenth century, the tower had to be rebuilt and later, in the 1870s, major work was required to the nave as the stone work was being damaged by acid rain. In 1847, when the Diocese of Manchester was formed, the Collegiate church became Manchester Cathedral, a status that it has enjoyed ever since.

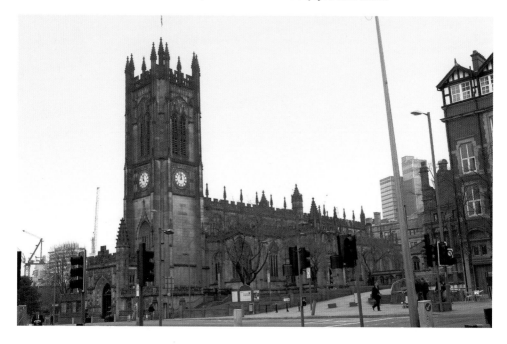

THIS VIEW OF the west end of Manchester Cathedral (above) shows the porch that was added in 1897 to commemorate Queen Victoria's diamond jubilee which also involved alterations to the lower part of the tower. Although the Cathedral was damaged during the Manchester Blitz in 1940 and by the 1996 bomb, its overall appearance has changed little since the beginning of the twentieth century. On the extreme right is a building that was constructed in 1906 and to its left the railings fence off the site of Hanging Bridge, a medieval bridge over Hanging Ditch, linking Cateaton Street with the churchyard. The structure of the bridge can be seen both from outside and from the basement of Hanging Bridge Chambers where the Cathedral Visitor Centre has refreshment facilities.

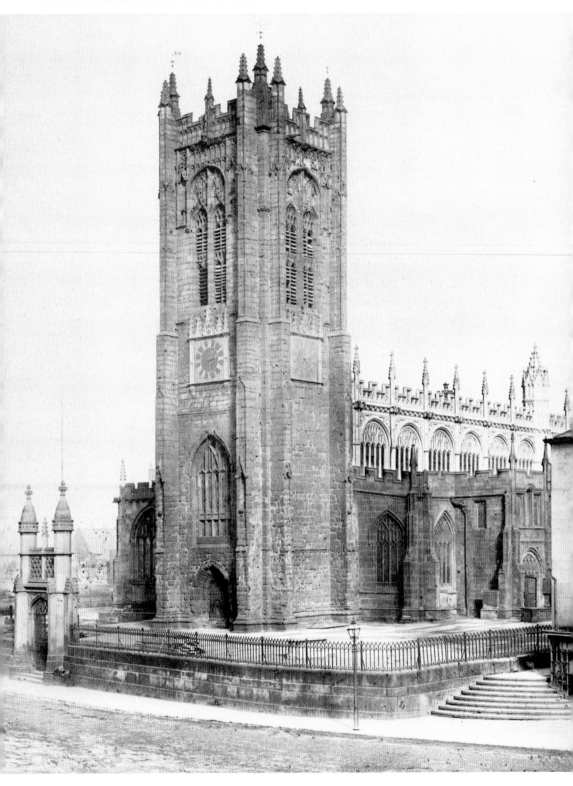

SMITHY DOOR

IN THE 1870S, the buildings on the triangular site between Deansgate, Victoria Street and St Mary's Gate, often referred to as Smithy Door, were demolished and replaced by Victoria Buildings, a development that included shops, offices and a hotel. The old photograph on the right shows the Victoria Hotel at the junction of Victoria Street (left), Cateaton Street and Deansgate (right) in the early twentieth century. The hotel had 140 rooms together with restaurants and a billiard room with 16 tables. According to a price list from the period, a single room cost 2s 6d (22½p) a day and a double room 6s 6d (32½p) a day. Guests paid an additional 1s (5p) for a fire in their bedroom and the same amount if they wanted a cold bath in the bathroom! The cost of breakfast ranged from 1s 6d (7½p) to 2s 6d (22½p) whilst the table d'hote dinner started at 5s (25p). The Victoria Hotel and the Victoria buildings were amongst those destroyed in the Manchester Blitz.

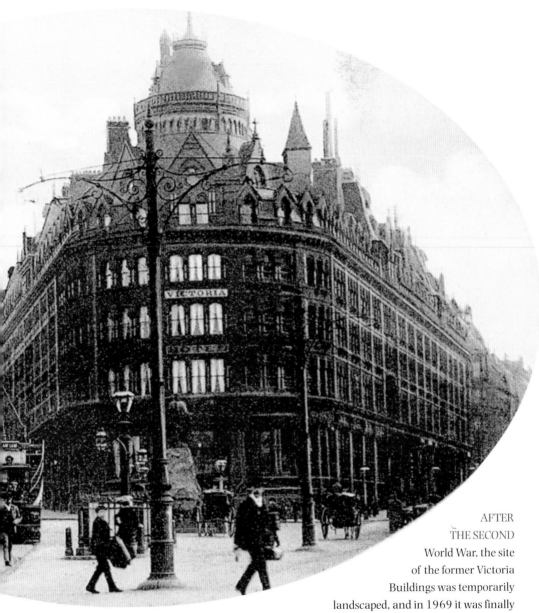

AFTER
THE SECOND
World War, the site
of the former Victoria
Buildings was temporarily
landscaped, and in 1969 it was finally
redeveloped, which involved the disappearance of part
of Victoria Street. The damage caused by the IRA bomb presented an opportunity to re-assess area,
and the result was the re-introduction of a new street roughly following the line of the former
Victoria Street. Marks & Spencers (left) was rebuilt and enlarged so that it covered the site of the
Old Shambles, which meant that the historic Wellington Inn and Sinclair's Oyster Bar needed to
be relocated. On the right is a completely new development, which is currently occupied by several
upmarket shops. Between the two developments, the re-introduction of a pedestrianised walkway
has allowed the Royal Exchange to be viewed again from this part of central Manchester.

MARKET PLACE

IN THE MIDDLE Ages, the Market Place was an important focal point in many communities and was often close to the parish church. In Manchester, the Market Place was relatively small compared with that in some other towns. When the town began to grow and attract more people to its market, the Market Place began to be very congested with the result that by the end of the eighteenth century, markets were to be found in several parts of the town centre, making it difficult for the Mosleys, who were lords of the manor, to collect tolls from the market traders and ensure that the rules regarding

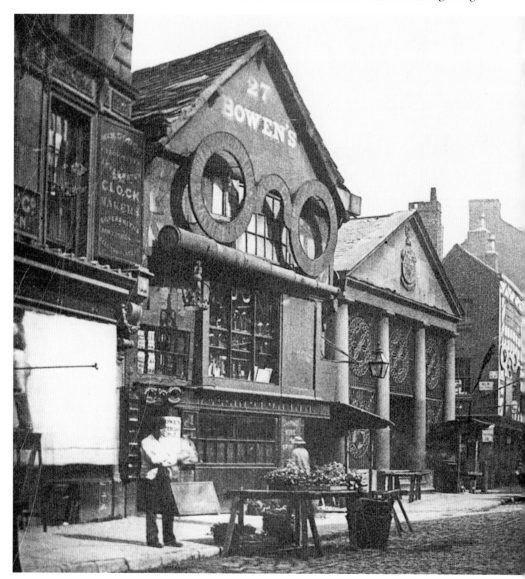

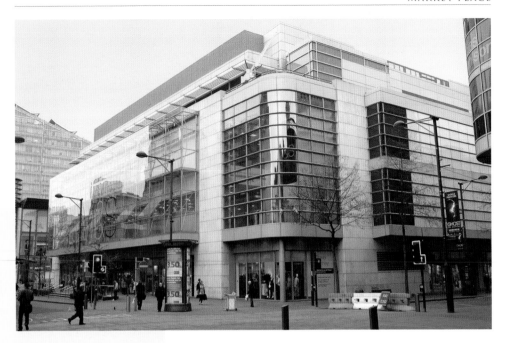

buying and selling were being observed. In 1821, it was decided
to centralise all the markets at Smithfield with a few stalls being
allowed to remain in the Market Place. The photograph on
the left, taken in about 1858, shows one of the few remaining
stalls together with the Wellington Inn and the Victoria Fish
and Games Market. The Wellington Inn was originally a private
house, obtaining a license to sell drink in the 1830s. When the
photograph was taken, the upper floors of the building were
occupied by Mr Bowen, an optician who proudly states that he is 'a
practical optician and mathematical instrument maker' and that
his business had been established in 1802.

THE MANCHESTER BLITZ of 1940 resulted in the destruction
of many of the buildings in and around the Market Place with
the only survivors being the Wellington Inn and Sinclair's Oyster
Bar. In the 1950s, the site at the corner of Corporation Street and
Market Street, backing onto the Market Place was re-developed
by Marks & Spencers, while developments in the 1960s and
early 1970s resulted in the area that had originally been the
Market Place being built over and the old buildings raised to fit in
with the new development. The modern photograph shows the
Market Street/Corporation Street corner of Marks & Spencers,
it not being possible to reproduce the viewpoint of the previous
photograph exactly, because it is now underneath the shop.

THE EXCHANGE

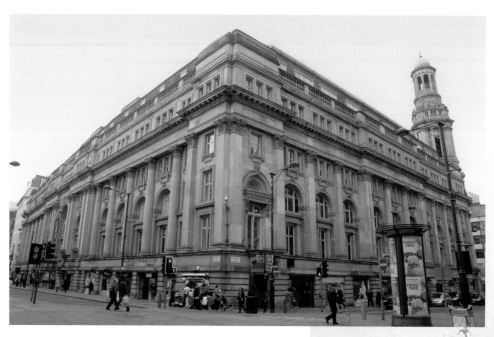

MANCHESTER'S FIRST EXCHANGE was erected in 1729,
but it failed to serve the purpose for which it was intended
and was closed and demolished in 1792. In 1809 a new
building, designed by Thomas Harrison, was opened at the
bottom of Market Street, opposite the Market Place, called
the Commercial Building but known to most people as
the Exchange. It included a newsroom, bar, several small
shops, such as tailors and hatters, aimed at those using
the building and a dining room that could accommodate
300 diners. During the nineteenth century, the Exchange
became the focal point for those engaged in all aspects of
the cotton industry, and it was enlarged at least twice in the
1840s. Between 1866 and 1874, the Royal Exchange was
rebuilt on an enlarged site, but by 1913, it was again in need
of further extension. On days of 'High Change' (Tuesdays
and Fridays) there could be as many as 6,000 people on the
floor of the Exchange at the same time. The photograph on
the right, taken in the early 1900s, shows the Cross Street
façade and the huge portico that was demolished when the
building was enlarged after the First World War.

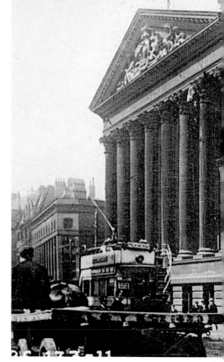

COMPARING THE MODERN photograph on the left with the early 1900s one below, it will be noticed that there is no longer a massive portico on the Cross Street frontage of the Royal Exchange. This was removed before the outbreak of the First World War as part of a deal with Manchester City Council not to oppose an extension of the building as the council wanted to widen Cross Street. By the time the extension was completed in 1921 and opened by George V, the cotton industry was beginning to decline and membership of the Exchange beginning to fall. In 1968 it was decided to close the Exchange floor, leaving the owners of the building with the problem of what to do with a large open area. This was eventually resolved when the Royal Exchange Theatre was established and a theatre erected on the floor of the Exchange.

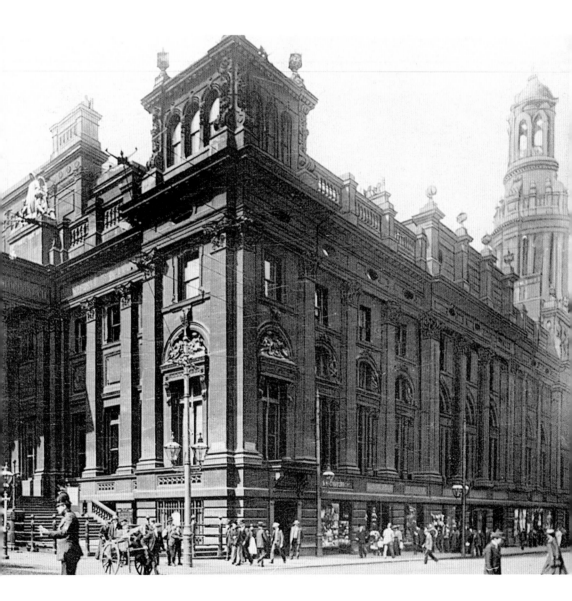

DEANSGATE

ALTHOUGH DEANSGATE IS the main east–west road through Manchester, in the nineteenth century it was rather narrow, leading to traffic congestion. Manchester City Council wanted to improve it but initially no agreement could be reached with the owners of the property on either side. Eventually, however, an agreement was reached and the road widened, the buildings on the southern side of Deansgate being set back to a new building line. As the Edwardian photograph below shows, the buildings on the northern side of the road were not affected by these changes. Here redevelopment was piecemeal, with Victorian buildings cheek by jowl with buildings from an earlier period. The small building next to the Midland Bank was replaced in 1910 by the offices for

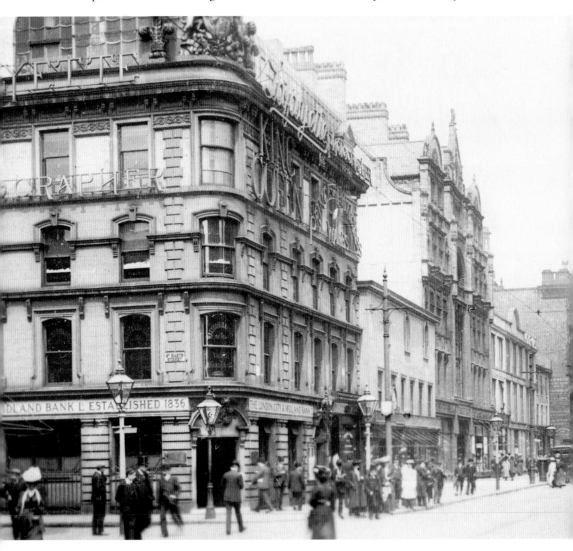

Manchester Diocese, known as Diocesan House, whilst further along, beyond the tall building, the Deansgate cinema was erected on the site of an earlier cinema. On the right there is the façade of Barton Buildings, the most impressive feature of which is Barton Arcade, completed in 1871.

THE IDEA OF people sitting at a pavement café is a relatively new development. The modern photograph of Deansgate above shows the two small buildings to the right of the tall building in the previous illustration. On the extreme left is the former Deansgate cinema that closed in 1990 and was converted into a public house named The Moon under Water. The building to its right was built for T Hayward and Company, described as 'high class glass and china dealers', and presumably shows the original building line of this side of Deansgate at the time. The church tower in the background is that of Manchester Cathedral, a view that was lost in the late 1960s when a pedestrian bridge was erected over this part of Deansgate. This bridge was demolished as part of the enhancement of the area after 1996.

ST MARY'S CHURCH

AS MANCHESTER'S POPULATION began to grow in the early eighteenth century, it was suggested that an additional Anglican church was required, but it was not until 1753 that authorisation was given for one. The site chosen was on land owned by the Collegiate church between Deansgate and the Irwell. The new church, dedicated to St Mary and said to be similar in appearance to Knutsford parish church, was completed in 1756. Originally the church had a steeple and a gilt ball and cross on top of the tower, but these had to be taken down in the 1820s and 1830s due to damage caused by high winds. In the latter half of the nineteenth century, the number of people living in central Manchester began to decline, giving rise to problems for some of the churches as their congregations fell. Around 1888 it was decided that St Mary's church was no longer viable so the church was closed and demolished. It was said that when it closed there were fewer people in the parish than attended St Mary's Sunday school in the 1790s.

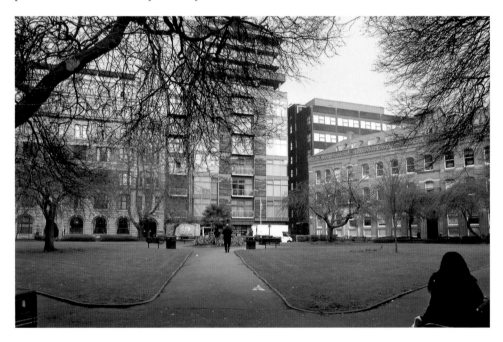

WHEN ST MARY'S church was demolished, it was not possible to build on the site as there was a large graveyard surrounding the former church. Rather than exhume the bodies and rebury them, the former graveyard was landscaped, creating a peaceful oasis in the centre of the city that formerly lacked any form of public open space. Surrounding the former churchyard can be seen buildings dating from the middle of the nineteenth century. The terracotta-clad building on the left is National House and was built between 1905 and 1909 to the designs of Harry Fairhurst at a time when terracotta was a popular choice for the exterior of buildings because the rain was said to clean the grime naturally off the material.

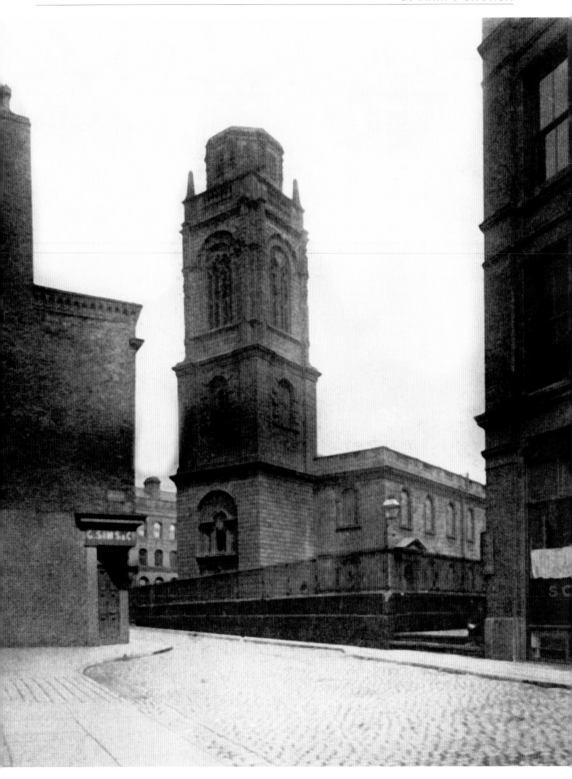

ST ANN'S SQUARE

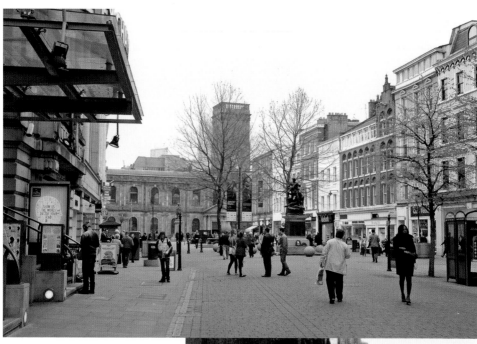

THE CONSTRUCTION OF St Ann's church was authorised by an Act of Parliament in 1708 and the church opened in 1712. Over the years, the appearance of St Ann's church has changed remarkably little, apart from the cupola on the top of the tower being removed in 1777 and the tower's height being increased slightly. One of the conditions stipulated in the act authorising the church's construction was that space should be left in front of the church to enable Manchester's annual fair to be held there, which it was until 1822 when it was moved first to Smithfield and then to Liverpool Road. St Ann's

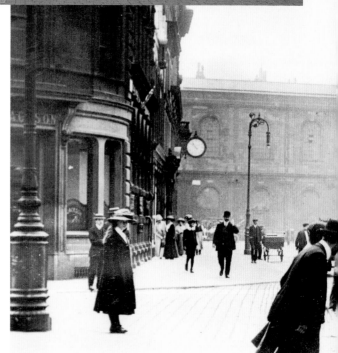

Square was originally a residential area but gradually, towards the end of the eighteenth century, it began to be transformed into a shopping area, with new buildings replacing the original residential properties. The early twentieth-century photograph of St Ann's Square not only shows the street scene at the time, but also the statue of Richard Cobden and, in the foreground, a memorial to Mancunians killed in the Boer War.

ST ANN'S SQUARE is one of the parts of central Manchester that has changed little over the last century. Someone returning to the square from the time of the photograph below would have no difficulty in recognising many of the buildings. The exclusion of traffic from the square and the planting of trees has created a pleasant traffic-free environment for pedestrians and a location where events, such as the Christmas Market, can be held.

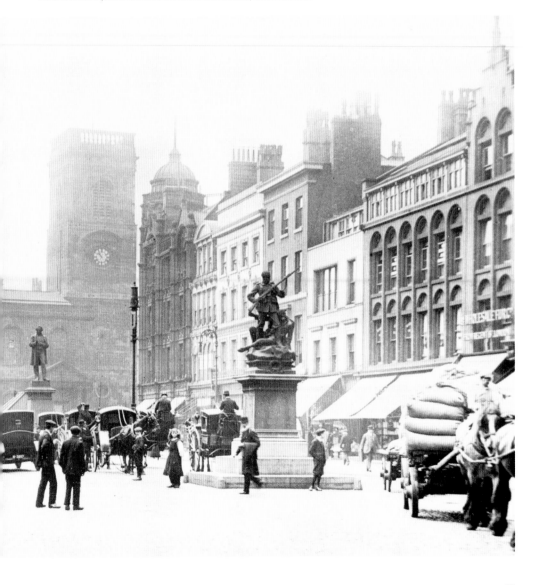

CROSS STREET CHAPEL

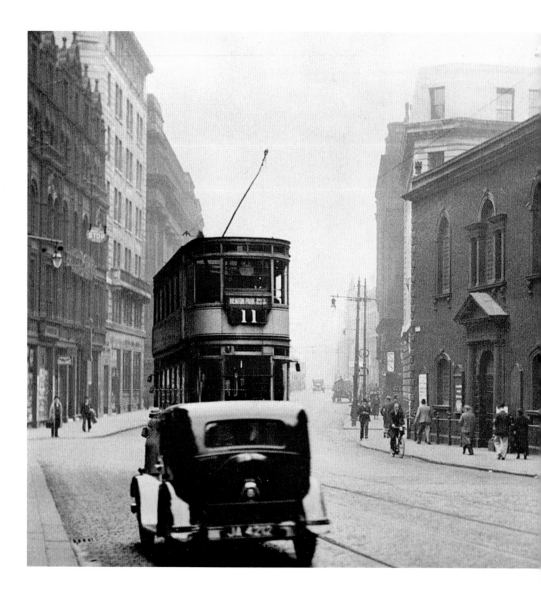

IN 1694, THE followers of the Revd Henry Newcome, a well-respected Presbyterian minister, completed a new place of worship on Cross Street to cater for his growing congregation. Although Newcome died in 1695, the congregation continued to flourish and expand. In 1715, the chapel was severely damaged by rioters supporting the Old Pretender. The cost of restoring it, around £1,500, was partly covered by money from central government. During the eighteenth century, the chapel gradually moved away from Presbyterianism and became a Unitarian Chapel, a denomination that attracted many of Manchester's businessmen and merchants. The building was

also used for meetings by organisations such as the Manchester Literary and Philosophical Society and Manchester Mechanics Institute until they could afford to built their own premises. In 1929, the chapel was described as the 'best brick-built building in Manchester', but unfortunately it was destroyed in the Christmas Blitz of 1940.

AFTER THE SECOND World War, Cross Street Chapel was rebuilt on its original site in a simple, unadorned brick style in keeping with the views of Unitarianism. In the 1990s, the site of Cross Street Chapel was redeveloped with an office block replacing the chapel, but as part of the agreement, a new chapel was included on the ground floor of the new building, thus continuing the site's use as a place of worship that claimed to be central Manchester's second oldest place of worship and the oldest Non-conformist chapel with continuous existence in Manchester.

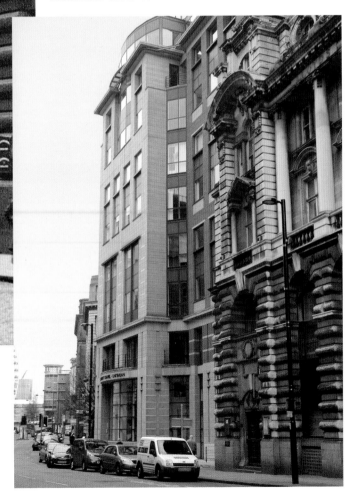

KING STREET

KING STREET IS divided roughly in half by Cross Street. The section between Cross Street and Deansgate came into existence in the 1730s as a residential area, but in the nineteenth century it gradually changed to one concentrating on retailing. The part of King Street between Cross Street and Spring Gardens is much wider than the other part, giving rise to the suggestion that it might have been planned as a square. During the nineteenth century, this part of King Street developed as Manchester's local government and financial centre, lined with imposing buildings, as the old

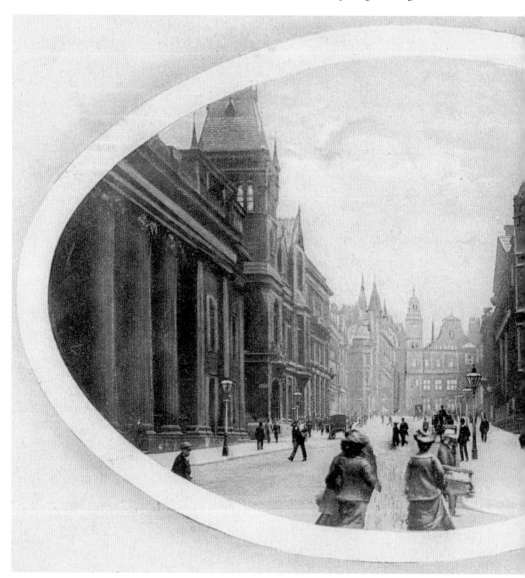

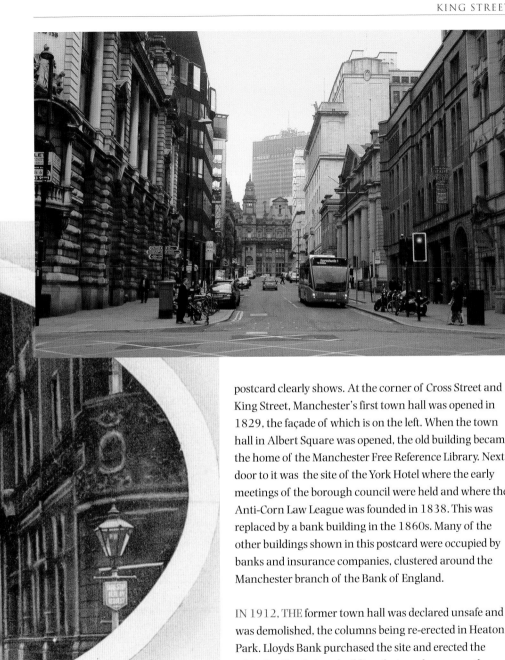

postcard clearly shows. At the corner of Cross Street and King Street, Manchester's first town hall was opened in 1829, the façade of which is on the left. When the town hall in Albert Square was opened, the old building became the home of the Manchester Free Reference Library. Next door to it was the site of the York Hotel where the early meetings of the borough council were held and where the Anti-Corn Law League was founded in 1838. This was replaced by a bank building in the 1860s. Many of the other buildings shown in this postcard were occupied by banks and insurance companies, clustered around the Manchester branch of the Bank of England.

IN 1912, THE former town hall was declared unsafe and was demolished, the columns being re-erected in Heaton Park. Lloyds Bank purchased the site and erected the white Portland stone building that can be seen on the extreme left. The classical-style building on the opposite side of the road was formerly the Manchester branch of the Bank of England, completed in 1845. The tall white building on the right was built in 1926 for the Manchester Ship Canal Company and beyond it is the Midland Bank, completed in 1929 to the designs of Edwin Lutyens.

CROSS STREET LOOKING TOWARDS MARKET STREET

ALTHOUGH CROSS STREET today links Albert Square and Market Street, this was not the case until 1829 when the rebuilding of Market Street enabled an entrance to be made into Cross Street. As well as improving the access to the town hall, the authorities took the opportunity to provide a single name for the whole length of the road instead of the three that had formerly existed. This illustration shows Cross Street, looking towards Market Street, around 1910, shortly after the

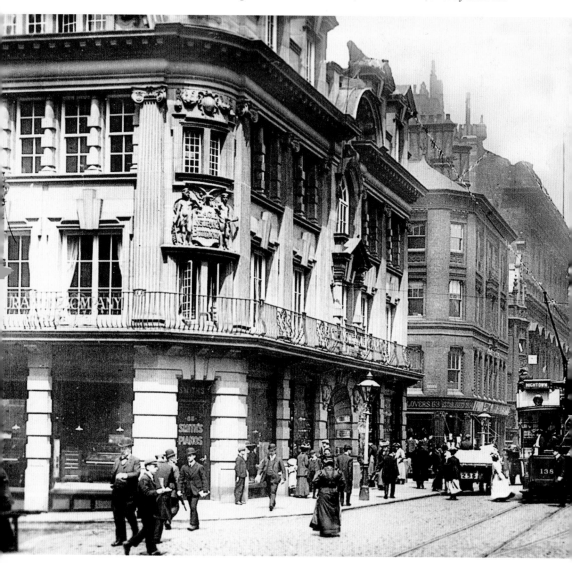

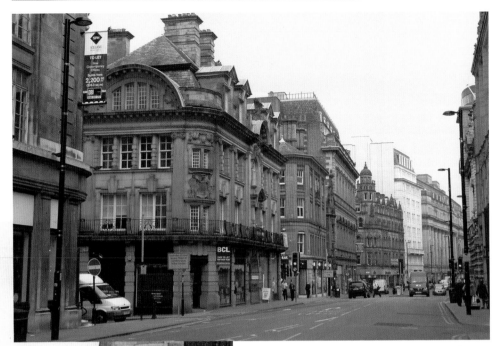

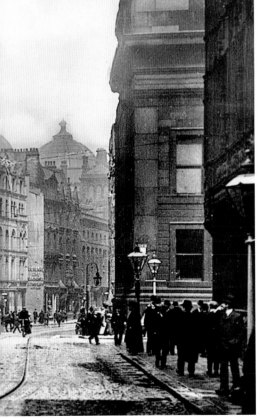

Eagle Insurance Buildings (extreme left) had been completed. Like many office buildings in Manchester that were constructed in the latter half of the nineteenth and early twentieth centuries, shops were located on the ground floor as a source of rental income for the building's owners. As the road bends slightly, the dome of the Royal Exchange is visible together with the buildings that were demolished in 1919 to make way for its extension.

THE SAME LOCATION in 2011 shows that many of the buildings on the left-hand side of the street have barely changed over the last century. The large white building next to the Royal Exchange was built after the extension to the Royal Exchange had been completed in the 1920s. The stone building on the right covers the site of the shop of John Benjamin Dancer who invented the microphotograph as well as the lantern slide and made scientific instruments such as microscopes and thermometers for scientists like John Dalton and J.P. Joule.

ALBERT SQUARE

WHEN PRINCE ALBERT died in 1862, Manchester honoured his memory with an impressive memorial designed by Thomas Worthington and housing a statue of Prince Albert given by Alderman Goadsby. The Albert Memorial was erected in a newly-created square where previously there had been several small factories, a coffee-roasting works and back-to-back housing. On one side of the new square was the Town Yard, where the town hall was eventually built, and the opposite side was lined with shops, warehouses and offices. When the picture on the right was taken, possibly around 1910, one of these buildings, to the left of the photograph, housed the publishers

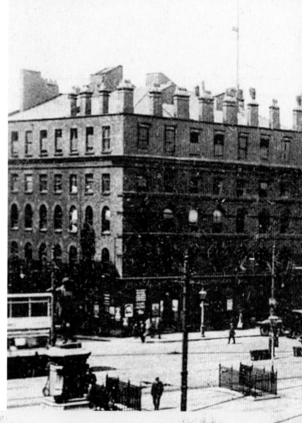

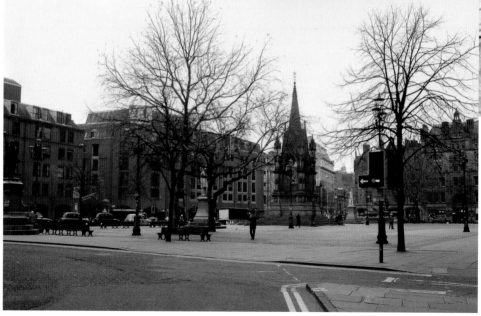

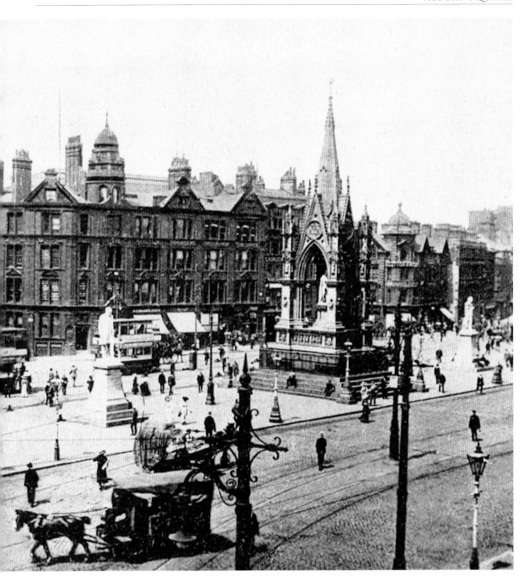

of *Bradshaw's Railway Timetables*, much loved by travellers in the nineteenth and twentieth centuries. Many of the offices in these buildings housed shipping companies who had established a representation in the city after the opening of the Manchester Ship Canal in 1894.

INITIALLY, ALBERT SQUARE had only a small paved area around the Albert Memorial and the other statues in the centre, but gradually the area of paving has been extended so that it is now no longer possible to drive in front of the town hall. The appearance of Albert Square was further enhanced in 1968 when the *Manchester Evening News* had a number of trees planted to mark its centenary. It is only in mid winter that it is possible to clearly see the buildings facing the town hall that were constructed in the early 1970s after much controversy about their design.

MOUNT STREET

MOUNT STREET RUNS gently uphill from Albert Square to Windmill Street where a 'cottage' known as 'The Mount' once stood alongside a windmill, on a site now covered by Manchester Central (formerly G-Mex). The name of Mount Street has been described as a 'humerous exaggeration', given the fact that the uphill gradient hardly exists. One of the earliest buildings on Mount Street was the meeting house of the Society of Friends, the gateposts and railings of

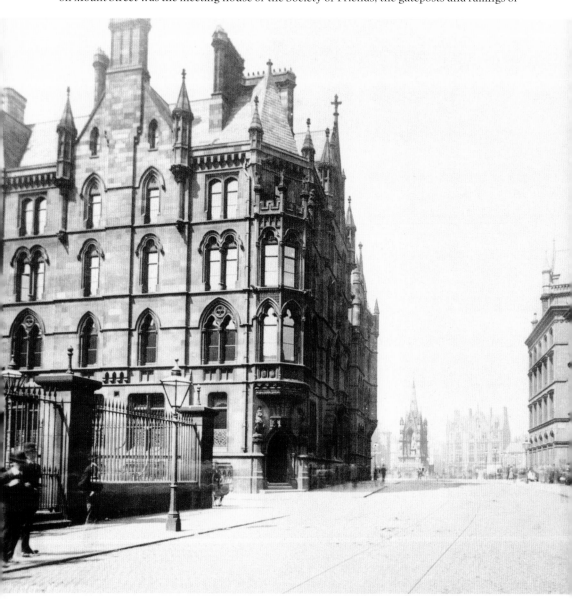

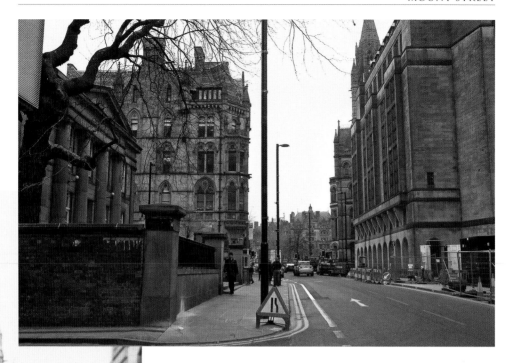

which can be seen on the left of the old photograph, taken in about 1878, on what appears to be a very quiet day, possibly a Sunday afternoon as the town hall clock indicates it is 2 p.m. The tall building on the left, built in 1874 and called Lawrence Buildings, was the Manchester office of the Inland Revenue for many years. The buildings on the opposite side of Mount Street were demolished when the Town Hall Extension and Central Library were erected in the 1930s. In the background, Albert Square is just visible with the Albert Memorial in the centre.

MOUNT STREET IN 2011 with the gateposts of the Friends Meeting House still visible although the railings have disappeared. Lawrence Buildings has also survived the passage of time although no longer used by the Inland Revenue. It is on the opposite side of the road that the greatest changes are visible. The attractive Victorian buildings in the previous photograph have been replaced by Vincent Harris's Town Hall Extension, completed in 1938, and on the extreme right is Manchester's Central Library, also designed by Harris. The road has also been narrowed as the demand for parking has increased, and trees partially hide the Albert Memorial and the buildings on Princess Street. The building work that is taking place on the right is connected with a major refurbishment of Central Library and Town Hall Extension, due to be completed around 2013.

ST PETER'S CHURCH

ST PETER'S CHURCH, shown below around 1866, was built in 1794 on the edge of Manchester, at the end of the road linking central Manchester with the Manchester and Wilmslow Turnpike in Chorlton-on-Medlock. The new road was named Oxford Street and was a broad, straight road that contrasted with the narrow streets of central Manchester. The church was designed by James Wyatt in the style of a Greek temple, and the tower that was added in 1816, a development that

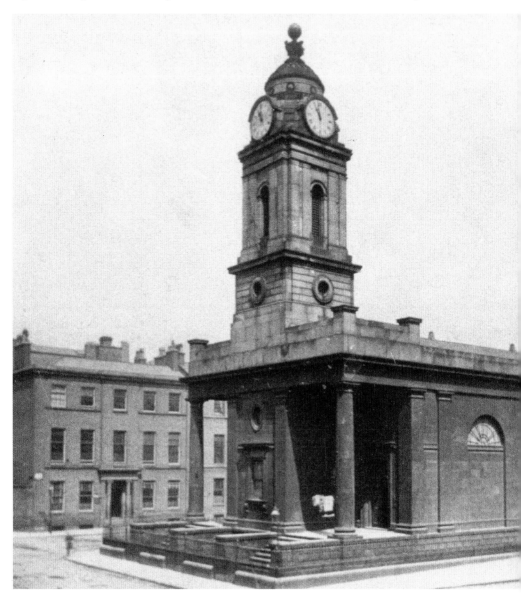

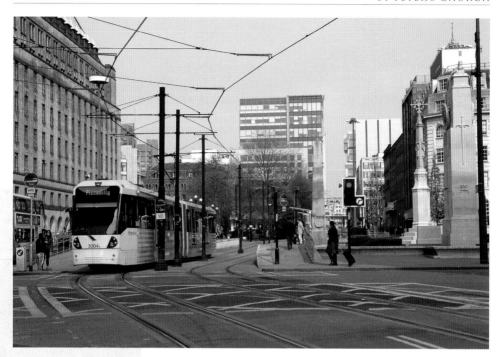

did not please Wyatt. Initially development in the area was mainly residential, but by the middle of the nineteenth century, places of entertainment and warehouses started to intrude and change the character of the area. The building of Central station significantly reduced the population of St Peter's church and it was left struggling to raise funds to survive. The church was closed in 1906 and was demolished the following year; the only clue to the site's former use was a white Portland stone cross, erected in the centre of what was essentially a traffic island and visible in the 2011 photograph above. This photograph was taken in about 1866 and shows the church dominating the surrounding property, which had only just been erected when the picture was taken.

SINCE THIS VIEW of St Peter's Square was taken in 2011, Manchester's Cenotaph has been relocated to the site of the former Peace Gardens between Mosley Street and Cooper Street. When the Cenotaph was planned, the original intention was to erect it in Albert Square and move the Albert Memorial to a new location. As the matter had not been resolved by 1924, it was decided to place the Cenotaph in St Peter's Square and move it to Albert Square once a decision had been made about the future of the Albert Memorial. No agreement could be reached, so the Cenotaph remained in St Peter's Square until 2014, when it was moved to its present location.

MANCHESTER
CENTRAL LIBRARY

ONE OF THE best known buildings in central Manchester is the circular Central Library in
St Peter's Square. The library was opened in 1934, replacing huts in Piccadilly that had served as

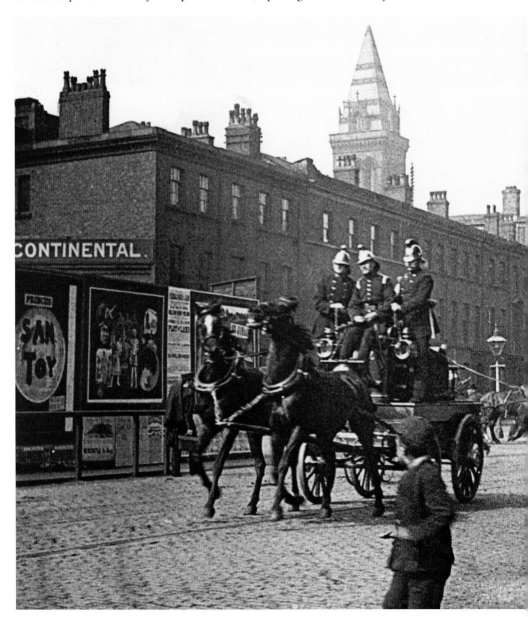

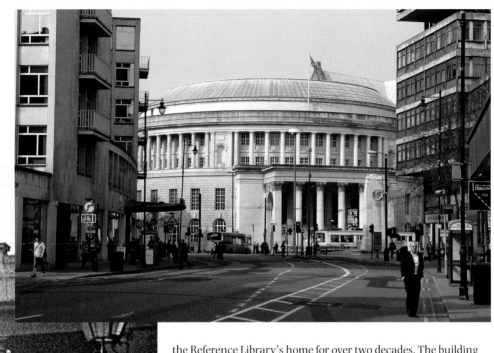

the Reference Library's home for over two decades. The building of the library involved the demolition of a block of three-storey properties that had been constructed in the mid-nineteenth century. These properties, which can be seen behind the horse-drawn fire engine, looked like domestic dwellings but were in fact offices, small workrooms and cafés. The tower in the background is on the Cooper Street, Lloyd Street, Princess Street corner of the town hall.

WHEN THE CENTRAL Library opened in 1934, it became the administrative hub for Manchester Public Libraries as well as housing the city's Reference Library, a general lending library, a Commercial Library and a Technical Library. During the 1950s and '60s, several new specialist departments were created, dealing with local studies, archives, music, the fine arts, language and literature. Hidden away in the library were around 40 miles of shelving and on them thousands of books, pamphlets and manuscripts. When the library opened, the printed word was all important, but as the twentieth century progressed, microfilm and microfiche material became available and were added to the library's stock. Today, computers are an important source of information, and in order to bring the building up to twenty-first-century standards, it has undergone a major refurbishment and is now open again to the public.

MANCHESTER THEATRES

DURING THE NINETEENTH century, Manchester's theatres became
established along Oxford Street and Peter Street. These theatres
included the Theatre Royal, the Princes, the Comedy (later the
Gaiety) and the St James Theatre, shown in this photograph (right).
The St James Theatre opened in 1884, described as 'the home of
heavy drama', and was the first theatre in Manchester to be affected
by the advent of the cinema; it closed in 1909 and was converted
into a cinema, but that too was closed in 1911. Next to the St James
Theatre was the St James Hall, used for concerts, bazaars and
exhibitions. It was in the St James Hall that John Tiller started to
train a troupe of young ladies that were later to become the Tiller
Girls. Both buildings were demolished to allow the Calico Printers
Association to build their new offices, known as St James Building.
A further place of entertainment was built in 1892 when the
three-storey buildings on the right were replaced by the Palace of
Varieties, which rapidly became Manchester's leading variety theatre
in Manchester, attracting the leading artists of the day such as Harry
Lauder, Vesta Tilly, Fred Karno and his army, and Stan Jefferson
(better known as Stan Laurel) to perform there.

THE CONSTRUCTION OF the Palace of Varieties (now known as the Palace Theatre) and St James Building changed the streetscape of Oxford Street, as the modern photograph shows. Since the Palace of Varieties opened, both its interior and exterior have been altered and refurbished on several occasions. In addition, the type of programme offered to patrons has also changed. After the First World War, the staple diet of variety shows was replaced by a mixture of plays, musicals, pantomimes, big band concerts, appearances of stars from the wireless and reviews, some of which were tried out in Manchester before being transferred to the West End in London. In the 1970s, Manchester had the Palace of Varieties and also the Opera House, and the general view was that the city didn't need both, so the Opera House was closed and the Palace of Varieties refurbished. However, it was soon realised that there was actually a need for two large theatres, one being used for long runs and the other for programmes that changed regularly. As a result, the Opera House re-opened, catering for long-running productions and the Palace of Varieties concentrated on shows that changed regularly.

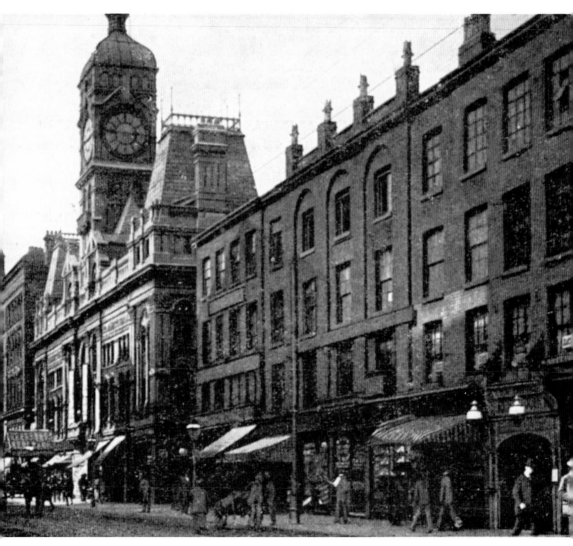

ST MARY'S HOSPITAL

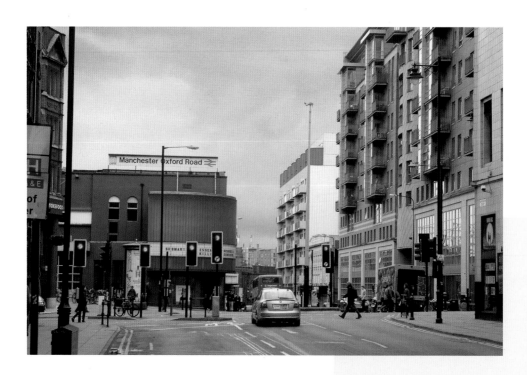

ST MARY'S HOSPITAL, founded in 1790 to provide
medical care for pregnant women and babies, had several
homes until it was moved to the corner of Whitworth
Street West and Oxford Street. Originally it occupied a
house close to Old Salford Bridge, then in 1804 it moved
to the former Bath Inn, Salford, then to South Parade,
near St Mary's church, each time occupying an existing
building. In 1856, it moved to a purpose-built maternity
hospital on Quay Street with between eighty and ninety
beds, but the move was not without problems: there were
complaints about dirty kitchens, poor quality food and a
lack of privacy for patients. Gradually things improved,
and the old hospital became inadequate. In 1890, the
Trustees of St Mary's acquired a site at the corner of
Oxford Street and Gloucester Street (now Whitworth Street
West) where it was proposed to erect a new hospital that
finally opened in 1903. The delay was caused by the failure
to agree a merger with the Southern Hospital for Women
and Children to secure of donation of £50,000 from the

David Lewis Trust. Shortly afterwards, a merge was agreed, the Southern Hospital closed and transferred its patients to the new hospital, which dealt with all maternity cases until 1911 when a new branch was built on the High Street, Chorlton-on-Medlock. The photograph below shows the Whitworth Street building after its closure in 1969 but before it was demolished.

WHEN THE HOSPITAL was closed and the buildings demolished, various suggestions were made about the use of the site but eventually, an apartment block with a shop and restaurant at street level was built. The small white building between the two apartment blocks is the Ritz Dance Hall, opened in 1928 when dance halls were all the rage. On the left is the Cornerhouse Cinema that occupies the site of a cinema opened in 1911 by Manchester Electric Theatres. When the cinema closed in 1923, the building became a furniture show room. A new building, known as the Tatler News Theatre, was erected and lasted until 1959, when it closed. Since then, the building has had a chequered history until it reopened in 1985 as part of the Cornerhouse Arts complex, showing films that have been described as 'Art House', which might otherwise not have been shown in Manchester.

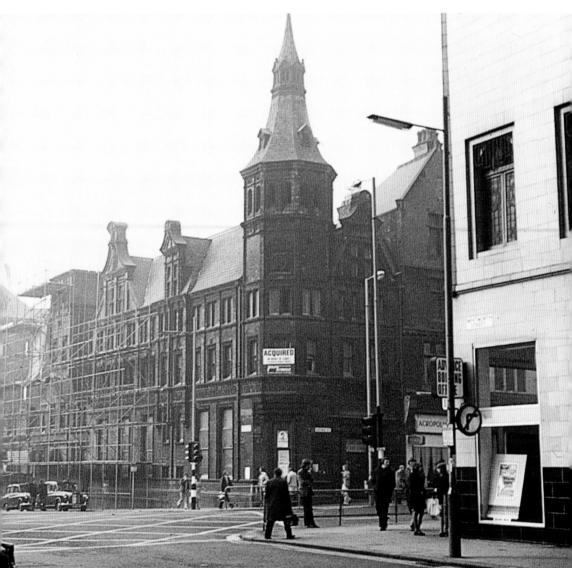

OXFORD STREET

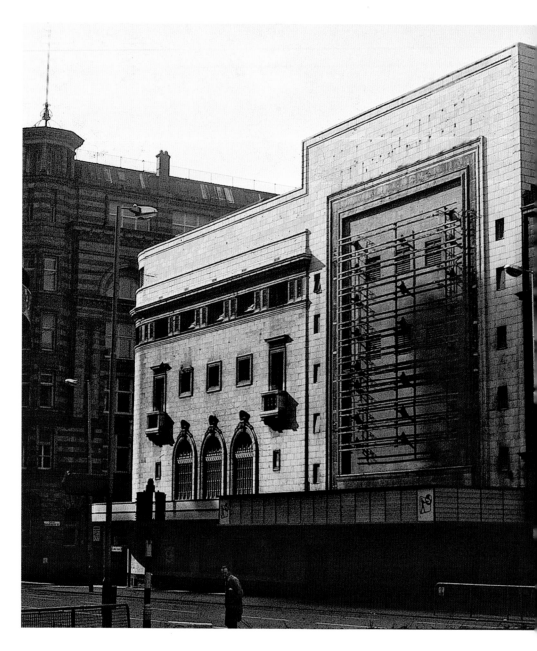

THE IMPORTANCE OF Oxford Street to Manchester's entertainment industry was further enhanced when on 16 December 1904 the Hippodrome, designed by Frank Mitcham for Oswald Stoll, was opened. The new theatre incorporated many original features such as a sliding roof over the auditorium,

an area which could be filled with water for 'water spectaculars', and stalls and cages under the stage for performing animals. The Hippodrome put on a variety of different types of programme ranging from variety acts to single-act plays and ballets, performed by some of the leading performers of the day. When the Hippodrome closed in February 1935, the name and the revolving sign from the roof were moved to the Ardwick Empire, which was renamed the Ardwick Hippodrome. In place of the Hippodrome a 2,500-seat luxury cinema was built that was named the Gaumont. It was opened by Jessie Matthews and her husband Sonny Hale and was said to have been the most luxurious cinema in Manchester. The foyer of the cinema ran the full length of the building and included the Long Bar that was popular with GIs during the Second World War. After the war, the Gaumont was used as a 'showcase' cinema for 70mm films filmed in Cinemascope, such as *South Pacific*. In 1984 the Gaumont closed was converted to a night club, closing in 1991 and, shortly afterwards, demolished.

AFTER THE GAUMONT Cinema was demolished, the site was redeveloped as a multi-storey car park with a restaurant on the ground floor. To the right of the car park is the former Picture House. Shortly after opening it became known as the Oxford Road Picture House, changing its name again in 1927 to the Oxford Theatre and then to the New Oxford Theatre. It closed in 1980 and was converted into a casino before being converted into a fast food restaurant. The building to the left of the car park was built as a warehouse in 1898 by Tootal Broadhurst & Lee, a major textile firm in the north west.

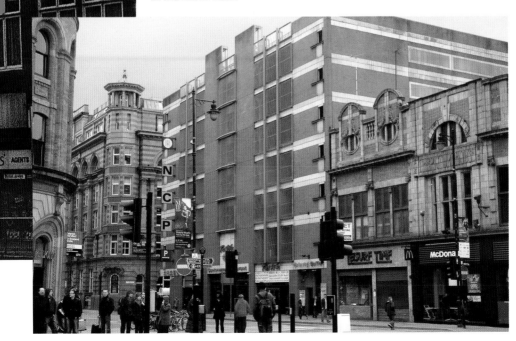

CENTRAL STATION

CENTRAL STATION WAS opened in July 1880 by the Cheshire Lines Committee, a railway company formed by the Manchester, Sheffield and Lincolnshire Railway, the Midland Railway and the Great Northern Railway to enable its constituent companies to have their own access to the Mersey estuary without having to rely on the LNWR. They also wanted their own terminus in Manchester, again independent of the LNWR so they could run services to London, north Cheshire and Liverpool in direct competition to the LNWR. The CLC services between Manchester and Liverpool rapidly gained a reputation for their regularity and punctuality, the fastest trains completing the journey in around forty-five minutes. The CLC also introduced the concept of the cheap day return and, to make things easier for both passengers and booking office clerks, fares were rounded down so that payment could be made using a single coin. The front of the station always looked unfinished as an office block planned to hide the engine shed

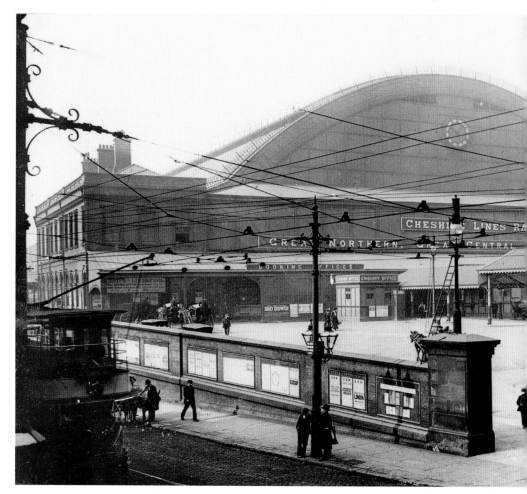

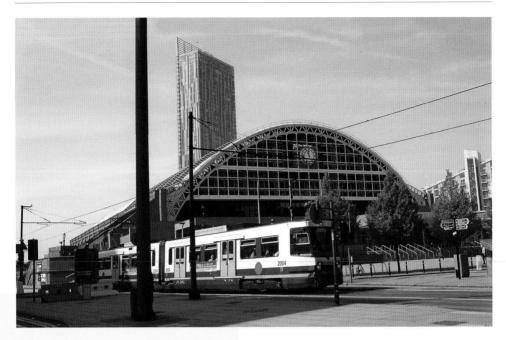

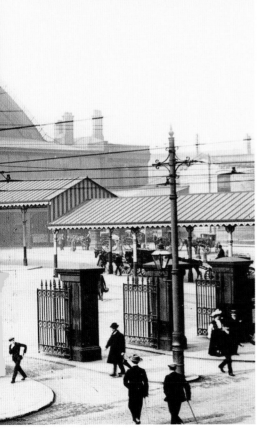

was never built. The old photograph, taken around 1910, shows the 210ft span of the engine shed area and the covered way erected to link the station to the rear of the Midland Hotel so that guests did not get wet walking between the station and their accommodation.

FOR OVER A decade after Central station closed in May 1969 there was concern over its future use. After being owned by several different individuals and companies, the former station was acquired by the Greater Manchester Council who, with private sector involvement, joined forces to turn the former station into a much needed exhibition hall in the heart of Manchester. The new G-Mex Centre was opened in the spring of 1986 and since then has been used not only for exhibitions, but also concerts and sporting events. More recently, conference facilities have been added at the side, thus increasing the potential usefulness of the building and the site as a whole. It has recently been renamed as Manchester Central, a reminder to an older generation of Mancunians of its days as a railway station.

LOWER
MOSLEY STREET

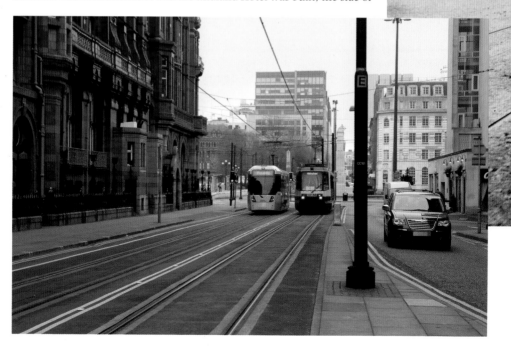

LOWER MOSLEY STREET came into existence at the end of the eighteenth century as a continuation of Mosley Street. In the first half of the nineteenth century, one side was lined with shops and houses whilst on the other stood several mills, including a silk mill, which provided employment for those living nearby. The photograph on the right, which was taken in 1897, shows Lower Mosley Street looking towards Mosley Street and central Manchester, the view along Mosley Street screened by St Peter's church. The buildings on the left comprise of the Lower Mosley Street Schools, the People's Concert Hall and the side of the Gentlemen's Concert Hall. In 1898, these buildings were demolished to enable the Midland Hotel to be built. Several of the buildings on the right-hand side of the picture survived until the 1970s, including the fish and chip shop and the public house next door to it. It is worth noting that these domestic buildings still retained the railing around their cellars.

BETWEEN 1898 AND 2011 the view the photographer took in the old photograph changed dramatically: the buildings on the left-hand side of the road were all demolished and the Midland Hotel was built, the side of

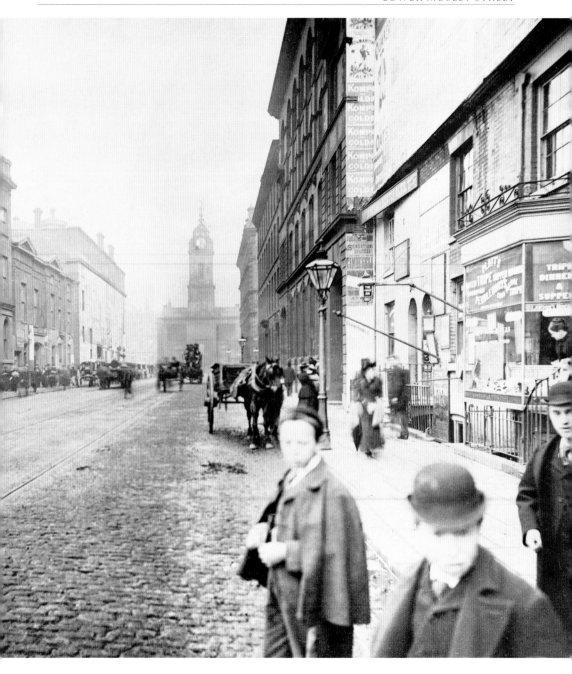

which can be seen in the modern photograph on the left. Whereas St Peter's church had blocked the view from Lower Mosley Street along Mosley Street to Piccadilly, now it is the Cenotaph that partially obstructs the view. On the right, the old warehouses have been replaced by modern buildings, one of which, St Peter's House, is partially visible on the left. Today the road is divided, with trams running on one side and other vehicles using the other – but only one way.

THE GENTLEMEN'S CONCERT SOCIETY

BETWEEN 1831 AND 1898, the corner of Peter Street and Lower Mosley Street was dominated by Richard Lane's Gentlemen's Concert Hall, built for the Gentlemen's Concert Society that had been founded in 1770. This building replaced their original concert hall behind Mosley Street that had become too small for the number of members wishing to attend concerts. Amongst those who performed in this building, which was said to have excellent acoustics, were Jenny Lind

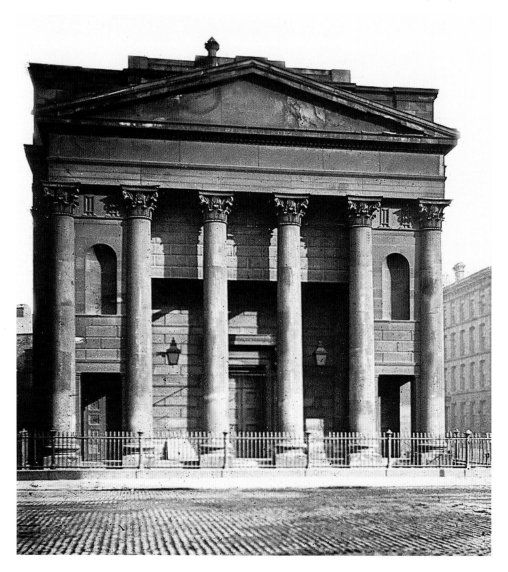

(the Swedish Nightingale), Frederick Chopin and Felix Mendelssohn. In 1848, Charles Halle was invited to perform with the orchestra, but he thought its standard was too low and threatened to return to London! However, he was eventually persuaded to remain, and was even appointed conductor, which vastly improved the standards of the orchestra. Halle resigned as conductor in 1855, although he remained associated with the society for the rest of his life. The last half of the nineteenth century saw a gradual decline in the fortunes of the Gentlemen's Concert Society as they faced competition from Halle's new orchestra and other concert promoters in Manchester. By the 1890s, major refurbishment of the building was required, but this was not possible, so in 1898 it was purchased by the Midland Railway and was demolished to enable the Midland Hotel to be built.

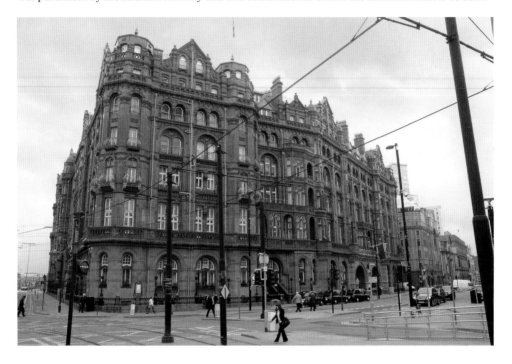

THE MIDLAND HOTEL, opened in 1903 on a site bounded by Windmill Street, Peter Street, Lower Mosley Street and Mount Street, was regarded as one of the most luxurious in the country with 400 bedrooms and 100 bathrooms, and modern conveniences such as electric lifts, restaurants, a roof garden and an orchestra to entertain guests whilst they were dining. There was also a small theatre incorporated into the building, intended for use by the Gentlemen's Concert Society, although they never used it. The theatre was used by Annie Horniman for a short season in 1907 before she established her repertory company at the Gaiety Theatre on Peter Street. In 1920, the theatre was converted into a cinema, but it closed in 1922 and the space was converted into bedrooms to meet the demand for accommodation. When the railways were nationalised, the Midland Hotel became part of the British Transport Commissions chain of railway hotels until it was sold off in the early 1980s and purchased by the partnership between the Greater Manchester County Council and Holiday Inns. The hotel was refurbished, re-opening in 1987, and has since become a top-class hotel, benefiting from its proximity to the Manchester Central Conference Centre.

THE FREE TRADE HALL

MANCHESTER'S FREE TRADE Hall was built by the Manchester Public Hall Company to replace an earlier building that had been built by the Anti-Corn Law League to hold fundraising events. Many members of the Anti-Corn Law League were involved in this new project, which was designed to commemorate the efforts to secure the repeal of the Corn Laws, hence the name 'Free Trade Hall'. Organisations and individuals were able to book the hall for any event, provided that its aims and objectives were 'within the law'. As a result, the building became an important venue for public

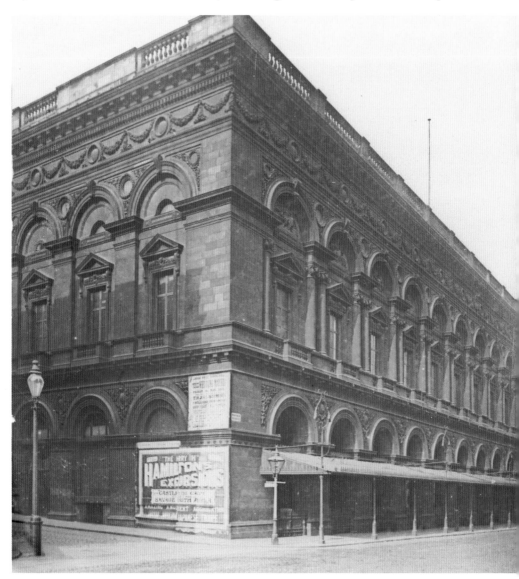

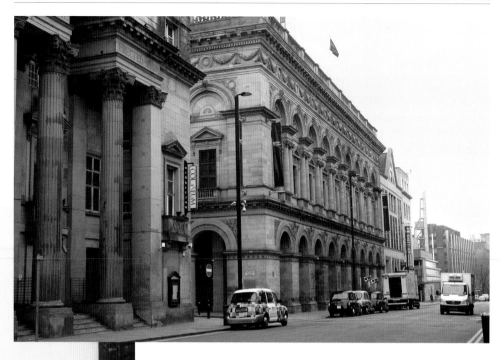

meetings, exhibitions and, above all, the home of Manchester's Halle Orchestra, which used the building until its destruction in the Christmas Blitz of 1940. The late nineteenth-century photograph of the Free Trade Hall on the right shows the canopy that covered the pavement to protect patrons from the weather when they left their carriages or taxis. Beyond the Free Trade Hall is the former Methodist New Connection Chapel, which was converted into a music hall in 1865 and which was subsequently destroyed by fire in 1927.

ONE OF THE suggestions put forward by Charles Halle in the nineteenth century was that Manchester should have a proper concert hall, but this was not achieved until 1996 when the Bridgewater Hall was opened. The question then arose of what to do with the Free Trade Hall, a building that had played such a significant role in both local and national events. There was a long debate about its future, and how much of the building should be retained, because only two façades were surviving from Edward Walter's original design (the Blitz had destroyed the original interior). Eventually, it was agreed that a hotel should be constructed within the original walls, allowing the two remaining original façades to remain. The Peter Street façade can be seen in the modern picture. To the left of the Free Trade Hall is the Theatre Royal, built in 1845, which not only staged plays, but also operas and pantomimes.

PETER STREET

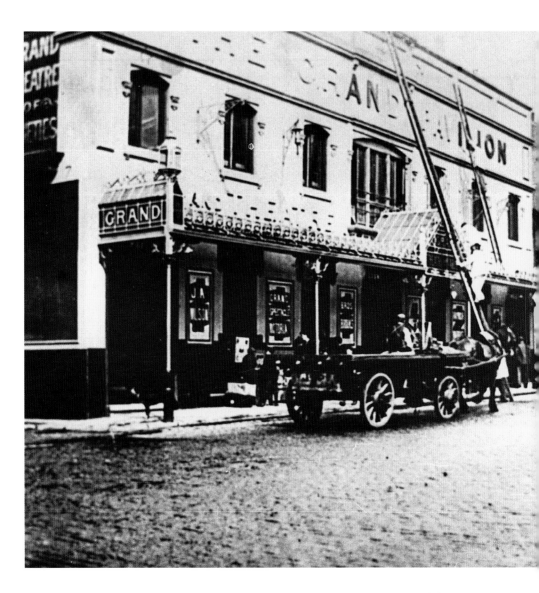

PETER STREET CAME into existence in the early 1790s when Oxford Street was extended to join Yates Street, creating an alternative route from south Manchester to Deansgate and Castlefield. In the early nineteenth century, Peter Street was mainly a residential street although there were small workshops in some of the houses. During the 1840s, changes began to occur as residential property was replaced by entertainment venues like the Theatre Royal, Gentlemen's Concert Hall, Free Trade Hall and the Folly, or Tivoli, Theatre. One of the original buildings on Peter Street was the New Jerusalem church, established in 1793, which can be seen to the right of the Grand Pavilion. As the residential nature of

the area declined in the 1870s and early 1880s, the church decided to move from central Manchester and established itself in Whalley Range. The buildings were taken over by the Trustees of the Whitworth Institute, who had taken over the Mechanics Institute, and used to teach spinning and weaving. The photograph on the left shows the former church, with the Grand Pavillion in the foreground. The Grand Pavillion was described as a 'second class place of entertainment' after its opening in 1883, and had a chequered history before being converted to a cinema in 1921 and finally closing in 1924.

AROUND 1909, THE former New Jerusalem church was acquired by the Manchester and Salford Methodist Mission who replaced the former chapel with a new building that dominated those surrounding it. This building was known as the Albert Hall and was used partly as a church and partly as a social centre where those working in the entertainment industry could relax. Eventually the ground floor was converted into show rooms, but the church remained active until 1969 when it was decided the congregation was to small to make it viable and it was closed. After many years of neglect, the building was found a new use as a pub. When the former Grand Pavilion (the building with the red-brick upper storey in the modern photograph below) closed, it was converted into a reading room for the Christian Science church that later moved to the other side of Peter Street, and their former place of worship was converted into a bar. The modern photograph also shows the side of the former Grand Pavilion on New Jerusalem Place and what might be the former auditorium of the theatre.

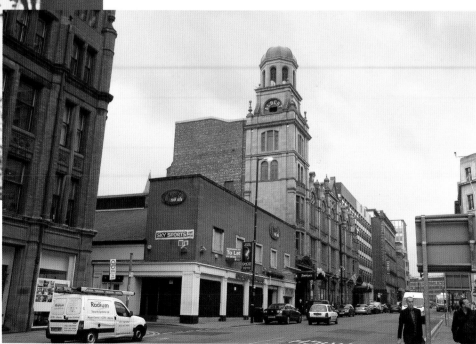

ST JOHN'S CHURCH

AS MANCHESTER EXPANDED in the latter half of the eighteenth century, it was recognised that there was a need for a new Anglican church on the edge of central Manchester. Edward Byrom and others promoted an Act of Parliament that authorised the building of a new church on the

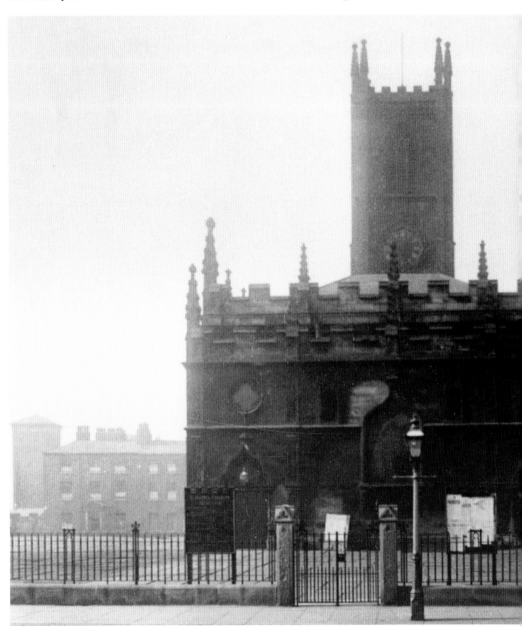

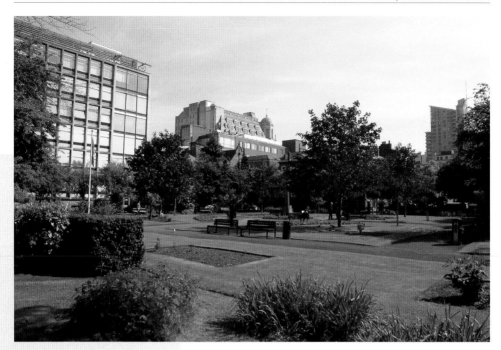

edge of the town. The new church, dedicated to St John, was consecrated in 1769 and rapidly became a fashionable church to attend, the main approach to it along St John's Street, was referred to as 'the carriage road to heaven'. Gradually the fashionable congregation moved away from the area as housing, industrial premises, transport facilities and commercial buildings developed in the surrounding area. The church survived until 1931 when it was closed and the building demolished around the same time as several other Anglican central Manchester churches.

WHEN ST JOHN'S church was closed and demolished in 1931, it was marked by the erection of a stone cross on which it was mentioned that over 20,000 burials had taken place in the churchyard including that of John Owens, who had left money that had resulted in the foundation of Owen's College, now Manchester University. Part of the churchyard was converted into a children's playground and the remainder into a pleasant seating area. Although the church has gone, some of the glass made by the well-known eighteenth-century York glazier, William Peckett, who also did work for York Minster, has survived and can now be seen in St Ann's church.

UPPER AND LOWER CAMPFIELD MARKETS

IN 1876, MANCHESTER abolished its traditional fair that had been held annually since 1222. The fair had been moved to Liverpool Road in 1823 where it gradually expanded so that by the 1870s, it was blocking not only Liverpool Road, but also Deansgate and the surrounding street. With the abolition of the annual fair, Manchester City Council decided to utilise the vacant plots of land to build a market hall to serve the local people. The existence of St Matthew's church prevented a large market hall being constructed so two smaller ones were built and became known as the Upper Campfield Market, shown here around 1902, and the Lower Campfield Market, just visible in the distance. Both buildings were completed between 1876 and 1878, but neither was successful in attracting traders or encouraging people to shop

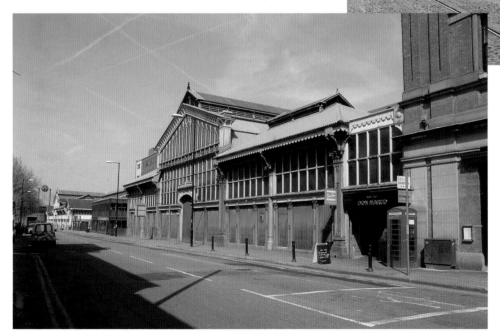

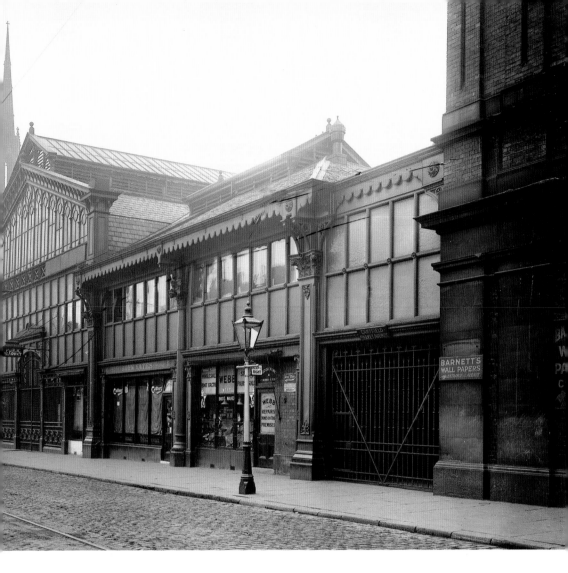

locally, the result being that both buildings became something of a white elephant. The Upper Campfield Market tended to be used by second-hand clothes dealers and similar traders, while the Lower Campfield Market was converted into an exhibition hall known as City Hall.

WITH THE CLOSURE of the Lower Campfield Market and the existence of the little-used Upper Campfield Market, the city council faced a difficult task of finding new uses for these buildings, which formed an important part of Liverpool Road's streetscape. In 1983, the Lower Campfield Market was converted into an Air and Space Museum, which ultimately became the Air and Space Gallery of the Museum of Science and Industry, but no satisfactory use could be found for the Upper Campfield Market. In 1996, it was used as a temporary home for the Royal Exchange Theatre Company after the IRA bomb caused damaged to the Royal Exchange. Since then, the Upper Campfield Market has had little use although there are now discussions taking place about converting it into a road transport museum using some of the exhibits from the Greater Manchester Transport Museum based at Boyle Street, Cheetham.

POTATO WHARF

THE PHOTOGRAPH ON the right was taken in the late 1970s and shows the corner of Potato Wharf and Liverpool Road. During the nineteenth century, there had been a number of ladder manufacturers on Liverpool Road, several of them from the Neild family. This small workshop, with its tongue-in-cheek name over the door, would have been typical of the type of small workshop that existed in this area during the nineteenth and early twentieth centuries.

IN THE EARLY 1980s, the Manchester branch of the YMCA based on Peter Street discovered that it needed to spend a lot

of money to restore its premises. At the same time, the original purpose for which it had been established had changed and so it was decided to sell the building, together with Montgomery House in Whalley Range, and replace it with a hotel in Castlefield. The new building, shown left, was built at the corner of Potato Wharf and Liverpool Road and incorporated a swimming pool and other leisure facilities as well as accommodation. Dominating the skyline is the Betham Tower that is part hotel and part residential accommodation, a landmark that can be seen for many miles around Manchester.

THE MERSEY
IRWELL WAREHOUSES

PRIOR TO THE building of the Bridgewater Canal from Manchester to Runcorn, the most efficient way to transport goods in bulk between Manchester and Liverpool was to use the Mersey Irwell Navigation, opened in 1735. The early warehouses were very simple constructions that often looked like private houses, but as the eighteenth century progressed they become larger and capable not only of holding goods in transit but also storing goods for a limited period. After 1830, river and canal warehouse

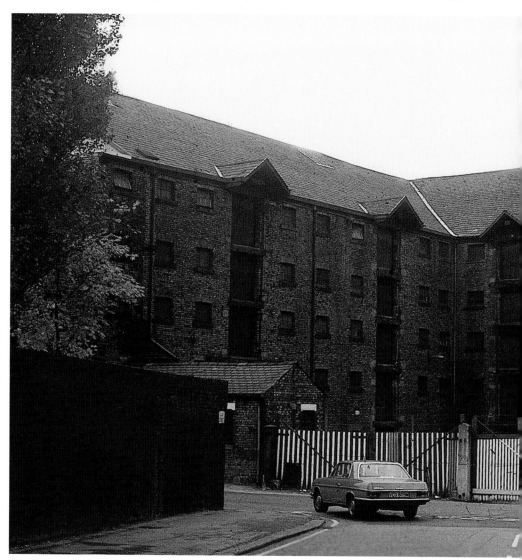

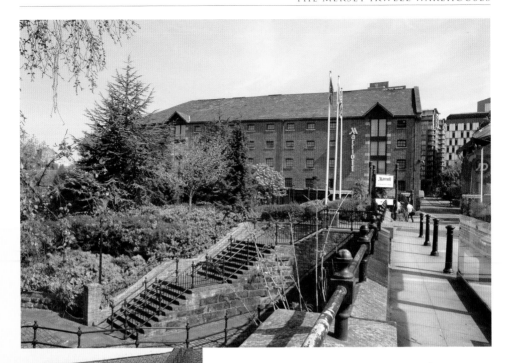

construction declined as the railways began to take an increasing amount of freight traffic between the two cities. Two of the last to be constructed for the river traffic were the Victoria and Albert Warehouses, completed around 1840, with their names proudly painted on the walls.

MANY OF THE Mersey Irwell Warehouses were demolished in the twentieth century, but the Victoria and Albert Warehouses survived. During the 1980s and '90s, the Castlefield area of Manchester became very popular with visitors not only to the Museum of Science and Industry but also to Granada Studio Tours. Rather than build a new hotel, the former Victoria and Albert Warehouses were carefully converted into a hotel, the exterior retaining the original small windows and replacing the doors through which goods passed with windows. Such careful preservation has meant that the warehouses look much as they always have done. Beneath the steps in the foreground is the entrance lock of the Manchester and Salford Junction Canal that linked the canals on the south side of Manchester with the River Irwell and the Manchester, Bolton and Bury Canal on the opposite bank in Salford.

93

THE ROCHDALE CANAL

THE OPENING OF the Rochdale Canal in December 1804 completed the link between the Bridgewater Canal and waterways of West Yorkshire, not only reducing the length of the journey between the east and west coasts of England but, at the same time, allowing factories along its route a choice of ports from which to import and export raw materials and finished products. Unlike most other canals, the Rochdale Canal was never taken over by one of the railway companies. It also escaped being included as part of British Waterways when the canals were nationalised after the Second World War. Although some traffic continued to use the canal well into the twentieth century, stretches of it fell into disuse, including the 'Rochdale Nine'

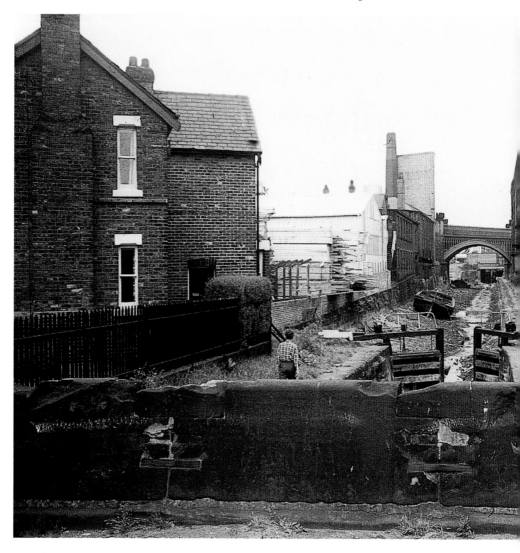

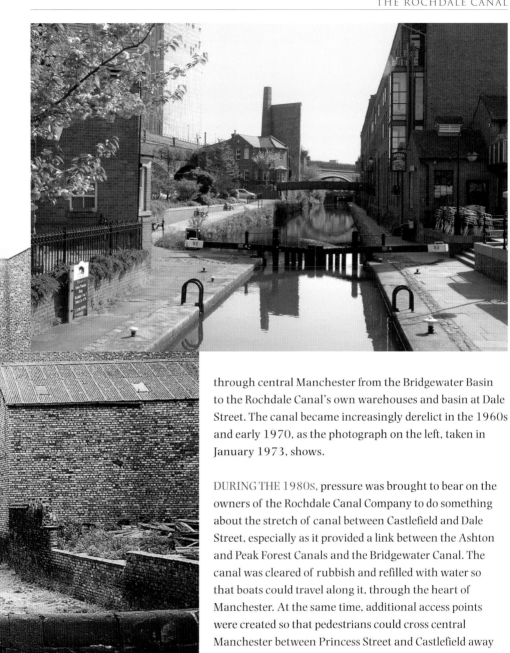

through central Manchester from the Bridgewater Basin to the Rochdale Canal's own warehouses and basin at Dale Street. The canal became increasingly derelict in the 1960s and early 1970, as the photograph on the left, taken in January 1973, shows.

DURING THE 1980S, pressure was brought to bear on the owners of the Rochdale Canal Company to do something about the stretch of canal between Castlefield and Dale Street, especially as it provided a link between the Ashton and Peak Forest Canals and the Bridgewater Canal. The canal was cleared of rubbish and refilled with water so that boats could travel along it, through the heart of Manchester. At the same time, additional access points were created so that pedestrians could cross central Manchester between Princess Street and Castlefield away from the traffic. The 2011 photograph above shows the transformation that has taken place: the timber yard has gone, although some buildings still remain on the site, and the buildings on the right, including a former tarpaulin works, have been refurbished and turned into offices. In the background are the viaducts carrying the railway and Metrolink trams away from the city centre.

Other titles published by The History Press

Manchester: From the Robert Banks Collection
JAMES STANHOPE-BROWN

This fascinating collection of archive photographs offers a rare glimpse of some of the events that were taking place in the city in the 1900s. Illustrated with over 130 snapshots, many never before published, of street scenes, buildings and the transport of yesteryear, as well photographs of whit walks, temperance marches, football matches and royal visits to the city, this absorbing book is an essential volume for lovers of photography and everyone with an interest in the history of the area.

978 0 7524 6013 0

More Lancashire Murders
ALAN HAYHURST

Alan Hayhurst brings together more murderous tales that shocked not only the county but made headline news throughout the nation. They include the case of Oldham nurse Elizabeth Berry, who poisoned her own daughter for the insurance money in 1887; Margaret Walber, who beat her husband to death in Liverpool in 1893; John Smith, the young Home-Guardsman who shot his ex-girlfriend in broad daylight at Whitworth in 1941; and many more.

978 0 7524 5645 4

Hanged at Manchester
STEVE FIELDING

For decades the high walls of Manchester's Strangeways Prison have contained some of England's most infamous criminals. Until hanging was abolished in the 1960s it was also the main centre of execution for convicted murderers from all parts of the north west. Fully illustrated with rare photographs, documents and news-cuttings, *Hanged at Manchester* is bound to appeal to anyone interested in the darker side of the north west of England's history.

978 0 7509 5052 7

The Golden Years of Manchester's Picture Houses: Memories of the Silver Screen 1900-1970
DEREK J. SOUTHALL

This is a delightful collection of memories from the golden age of cinema in Manchester. Filled with archive images and humorous recollections, it looks back on courting days and wartime air raids, the stars, the staff and all the magic of the silver screen.

978 0 7524 4981 4

Visit our website and discover thousands of other History Press books.
www.thehistorypress.co.uk